C. Smith

IMAGES
of America
HANFORD
1900–2000

IMAGES
of America

HANFORD
1900–2000

Robin Michael Roberts

ARCADIA
PUBLISHING

Published by Arcadia Publishing
Charleston SC, Chicago IL, Portsmouth NH, San Francisco CA

Printed in the United States of America

Library of Congress Catalog Card Number: 2007923427

For all general information contact Arcadia Publishing at:
Telephone 843-853-2070
Fax 843-853-0044
E-mail sales@arcadiapublishing.com
For customer service and orders:
Toll-Free 1-888-313-2665

Visit us on the Internet at www.arcadiapublishing.com

To Thomas Wayne Davis III, my first-born grandson and the first to be born outside of California in five generations, in the hope that someday he will come home.

CONTENTS

ACKNOWLEDGMENTS

I would like to thank Louise Hodges, Kings County librarian, for giving me permission to paw through the library photograph collection once again; Sherman Lee, Hanford Branch reference librarian, for his assistance in researching background information; and Gail Lucas, Hanford Branch librarian, for assisting in accessing the photographic files. At the Hanford Carnegie Museum, Director JoAnn Gibbons and volunteer David Vierra both spent many hours assisting my search through museum files. David, particularly, was good company and shared his knowledge, memories, and personal photographs for many long hours. His enthusiasm for local history and the Carnegie Museum are tremendous assets to the community. Longtime educational technology colleague Ed Bishop took some important photographs that appear in the book.

I would like to salute my fellow preservers of Hanford history: Michael Semas, whose postcard collection is invaluable to the preservation of local history and whose book complements mine; Dave Rantz and Alice Stevenson, who many years ago took many of the photographs that appear in this book; Jack Stone, who preserved so many historical photographs over the years, including many that appear in this book; and the members of the Hanford and Kings County Centennial book committees, who cataloged and preserved so many valuable photographs in the early 1990s. Harold "Hoot" Gibson's history of Kings County schools provided much-needed information.

Daughters Terra King and Tamara Davis and my wife, Sylvia Roberts, gave me support, encouragement, and assistance; Dr. Patti Chance, University of Nevada, Las Vegas, allowed me time from my duties to work on this book; and my friend and schoolmate at University of Nevada, Las Vegas, Milan Jelenic, provided moral support. My good friends Kerry and Heidi Arroues supported the book in many ways and deserve recognition for their contributions to Hanford and valley history and culture. Nicole Devol helped identify members of the Voices of Illusion and traveled across the United States to visit her friend Tamara and new son, Thomas, to whom this book is dedicated—that is friendship.

INTRODUCTION

In this, the follow-up to Images of America: Hanford, California, is the continuing story of the small town in the big valley. Hanford did not stay small for long. Today it is a thriving city of almost 50,000 people—up from 2,929 in 1900. Today retail business and industry are important parts of its economy, but make no mistake: Ag is still king in Kings County.

Unlike the earlier book, this one is solely about Hanford and only peripherally about Kings County. Over the last century, Hanford has developed its own unique personality that makes it no longer simply the population center of an extended agricultural community. Hanford is more than Seventh and Irwin Streets and the Southern Pacific Railroad tracks. It is as much a suburban, shopping mall sort of town as it is a center for some of the world's largest farms. By itself, this is not unique, but what sets Hanford apart from other similar towns is an effort on the part of its citizens to maintain a small-town sense of community within the context of a city.

With "Planning Tomorrows" as its motto, Hanford's historic downtown center has been preserved—as a glance through these pages will show—and its roots as an agricultural community kept alive through old traditions such as Kings County Homecoming Days and new ones like the farmer's market. Hanford, unlike many other towns, did not tear down its older buildings; it recycled them, turning them into showpieces of period architecture and civic pride. People now come to Hanford to see Hanford—not just to ship hogs or ride Amtrak.

As a result, Hanford was awarded the Helen Putnam Prize as an outstanding, small American community and named a Tree City USA several times. It has been profiled in numerous travel magazines, numbered among the prettiest painted places in America, and is a desirable place to live, attracting an astonishing variety of new businesses and industrial partners to its environs.

Unfortunately, some of Hanford's landmarks are falling prey to this growth. In 2006, the world-famous Imperial Dynasty closed its doors, and Fort Roosevelt was dismantled and razed—with the exception of one historic building that was saved and transported back from whence it came. There is really no one to blame for this—they are simply the latest in a long string of endings that can be traced through this book, but that does not diminish the impact of their loss.

Hanford is not only about buildings or businesses; it is about the people who call it home. Housing construction is today at an all-time high, and businesses are flocking to Hanford in ever greater numbers because of it. Recent estimates suggest that the population of Hanford will double in the next 25 years as a result of this continued growth. Whether Hanford retains its unique character in the face of this growth depends largely upon whether those future residents develop a sense of Hanford's history and come to claim that history as their own—that is what this book is about.

Three themes—people, places, and events—are the focus of the book. Organized by decade, each chapter has an individual historic setting, but the three themes tell the continuing story. Chapter one follows the introduction of the automobile, and chapter two traces the changes this brought about. In chapter three, Hanford celebrates its 50th birthday but sees hope fade in the face of the stock market crash. During the Depression years detailed in chapter four,

Hanford resists the nationwide economic woes and moves ahead with life. World War II comes to Hanford in chapter five, while chapter six follows the postwar recovery and celebration of the California Centennial. During the 1960s (chapter seven), Hanford celebrates its 75th birthday and welcomes its biggest-ever industrial partner. Chapters eight, nine, and ten trace how Hanford kept its small-town persona intact in the face of extraordinary growth. The story presented here is neither complete nor comprehensive. Many will be disappointed that a favorite person, place, or story has been left out—each such omission has been made reluctantly and with regret that more time, space, and resources were not available to include them all.

Among those who appear in these pages are such well-known Hanford natives as Nobel Laureate James Rainwater, track legend Dutch Warmerdam, world-champion cowboy Cuff Burrell, and celebrated artist Henry Sugimoto. Aviatrix Amelia Earhart, civil rights leader Cesar Chavez, Sen. John F. Kennedy, first lady Eleanor Roosevelt, trial lawyer William Jennings Bryan, and Gov. Earl Warren are all part of the Hanford story. Many other Hanford notables are not included—often because photographs were not available or permission to use them could not be obtained.

Hanford's sons and daughters have excelled in almost every field of human endeavor. For instance, in the field of entertainment Steven Anderson won an Emmy Award for special effects for *War and Remembrance*. Scott Alexander cowrote *Spaced Invaders*. Steven Downing produced the *McGyver* series and was a scriptwriter for *T. J. Hooker*. Actress Lillian Albertson was chief of the dramatic coaching staff at RKO Studios. Other actors and actresses from Hanford include Pauline Lord, "Slim" Pickens and his brother "Easy" Pickens (Louis and Eugene Lindley), Wayne Alexander (Jack Webb's sidekick in *Dragnet*), Jan Michael Vincent of *Airwolf* fame, and adult film legend Adam Porn (Bernie Hornsby).

Athletes from Hanford include Bill Renna (MLB Yankees), Bill Landis (MLB Red Sox), Ken Caminiti (MLB Astros, Padres), Tim Scott (MLB Dodgers, Padres), Ryan Bowen (MLB Astros, Marlins), Mark Lee (NFL Packers), Jewerl Thomas (NFL Rams, Chargers), Pete Verhoeven (NBA Trailblazers, Warriors, Pacers), Tyson Chandler (NBA Bulls), Scott Parker (the first Californian to play in the NHL), Shawn Wills (NFL and MLB), Frank Armi (Indianapolis 500), Francis Eisenlaur (world-class skeet shooter), and Troy Barnhart (water polo, All-American, Olympian), among others.

In music, the Melody Ranch owned by Noble Fosberg south of Hanford discovered Jean Shepard, a regular on the *Grand Old Opry* who became a top female country-western singer during the 1950s and 1960s. Steve Perry, lead singer of rock legend Journey, was born in Hanford and raised locally.

Maguerite Colby, the famous "Lost Bird" of Wounded Knee, married Earnest Allen of Hanford, and they lived here until her death in 1920. Susie Bianco and Joe Gallo met and married in Hanford and were the parents of Ernest, Julio, and Joseph Jr. of wine and salami fame. Susie's sister Celia married Joe's brother Mike Gallo here as well.

The connections with the well-known are many, but they should not overshadow the lives of the people who are not so well-known but call Hanford home. Most residents, such as Herbert Works, who worked at Hanford Hardware starting the day after he graduated from Hanford High School in 1920 until he retired and sold the business in 1968, are content to live peaceful, happy lives among family and friends and leave a legacy not in name or in fame but in the sons and daughters, grandchildren, and great-grandchildren who call Hanford home. This book is for them. Please visit the book's Web site, www.hanfordhistory.com.

One

KING OF KINGS
1900–1909

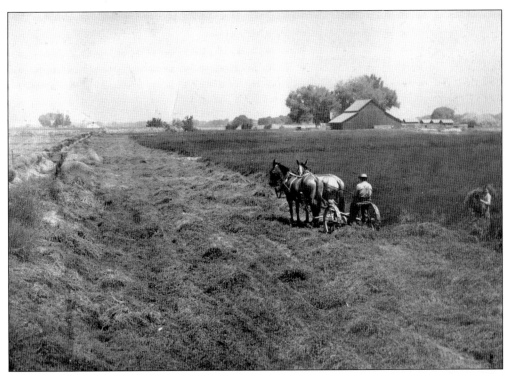

At the beginning of the 20th century, Hanford was still a town based on agriculture. The photograph above, taken in a field near Hanford around 1900, depicts the horse-drawn equipment that was typical for agricultural work at the time. That was soon to change as Hanford, along with the rest of America, underwent the revolution caused by the invention of the automobile. (Courtesy Kings County Museum.)

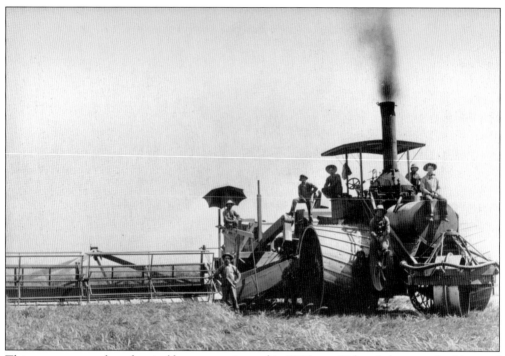

This steam-powered mechanical harvester, pictured in 1905 near Tulare Lake, was a harbinger of what was to come. The world was changing, and Hanford changed with it—although not always at the same pace. (Courtesy Kings County Museum.)

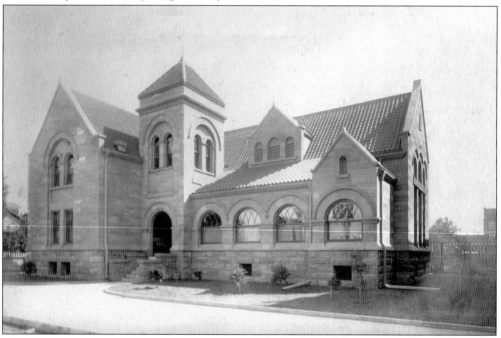

Change did not only occur with agricultural practices, rather the city of Hanford itself was changing. Among these changes were improvements in services and infrastructure, such as the Carnegie Library—now the Carnegie Museum—built in 1905. (Courtesy Hanford Carnegie Museum.)

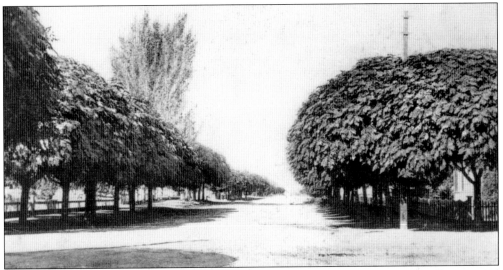

Hanford was a much smaller town in 1900 than it is in 2007. This is illustrated by the postcard above, showing Harris Avenue at the start of the century. At the time, it was familiarly called "Umbrella Avenue," probably because of the trees that lined both sides of the street. (Courtesy Kings County Library.)

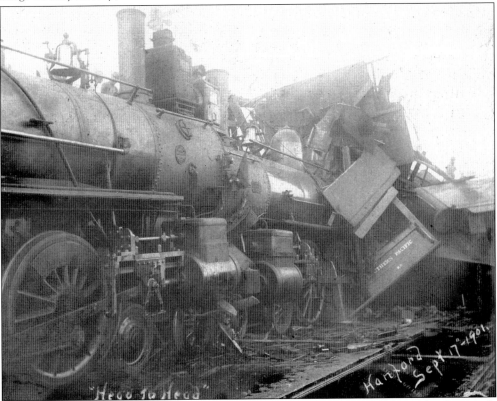

Railroads still provided the main link between Hanford and the rest of the world, but as the photograph above shows, they did not always do so flawlessly. This head-to-head train wreck involving Southern Pacific trains occurred on September 17, 1907. (Courtesy Kings County Museum.)

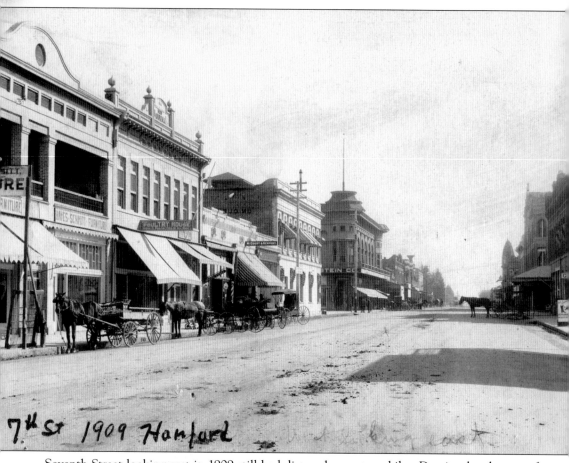

7th St 1909 Hanford

Seventh Street looking east in 1909 still had dirt and no automobiles. Despite the absence of cars, traffic was still a problem. A sign halfway up the street reads "Slow Down to 8 MPH." Pictured from left to right are the Hayes-Schmitt Furniture Store, the High Lake Poultry Shop, the Hanford *Journal*, the Unique Barber Shop, the McCourt and Newport Law Offices, and the Horlock-Clow Company. On the next block is the Kutner-Goldstein Department Store, with its distinctive cone-shaped tower, and the Cousins and Howland Drug Store with its landmark mortar and pestle. On the right-hand side of the street are Ole J. Lundemon's Shoe Repair, a gun shop, and Barney and Kelm. Notice the telephone and power poles that run down the north side of the street—these disappeared in later years. By the way, the substance that can be seen in the center of the street is not mud. (Courtesy Kings County Library.)

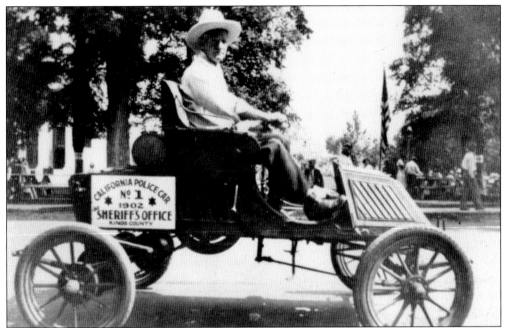

Among the first cars in Hanford—if not the first—is the car shown above. Originally purchased by Sheriff William Van Buckner, this 1902 Model E is believed to be the first car purchased for use by a law enforcement agency in the state of California. (Courtesy Hanford Carnegie Museum.)

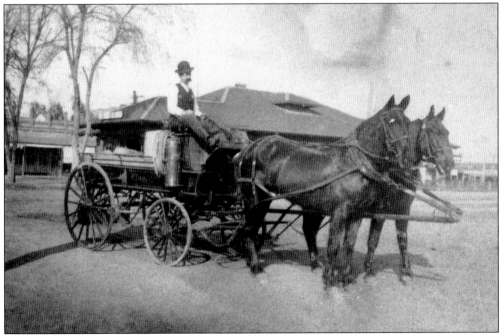

Apparently the fire department was not as progressive as Sheriff Buckner. George T. Howard is shown at the reins of Hanford's first fire wagon in this 1905 photograph taken at Douty and Sixth Streets. The Southern Pacific depot is in the background. (Courtesy Kings County Museum.)

The old Kings County Jail is pictured in 1901. Deputy Sheriff Andy Avers stands on the steps under bunting and a large photograph memorializing the late president William McKinley, who was assassinated September 6, 1901. The jail was completed November 1, 1898, and served as the Kings County jail until 1964. Today it is the Bastille restaurant (see page 121, top). (Courtesy Kings County Library.)

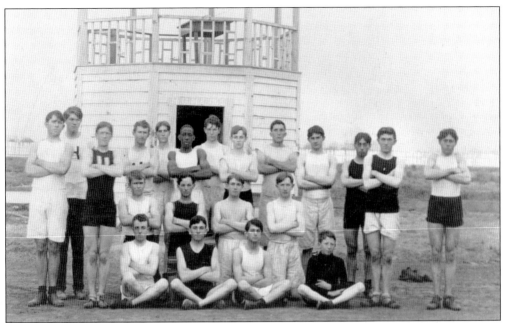

The Hanford High School boy's track team is pictured at the fairgrounds in June 1906. Team members, in no particular order, are Sam Bellart, Arthur Kerran, Ralph Blowers, Lloyd Helcher, Fred Wilkenson, Roy Newport, Justin Miller, Charles Furby, Vic Hahze, Herndon Hitchcock, Charles Young, Russell Taylor, Raymond Ayers, Hal Weisbaum, Marion Hefton, and Lawrence Phillips; four members are unidentified. (Courtesy Hanford Carnegie Museum.)

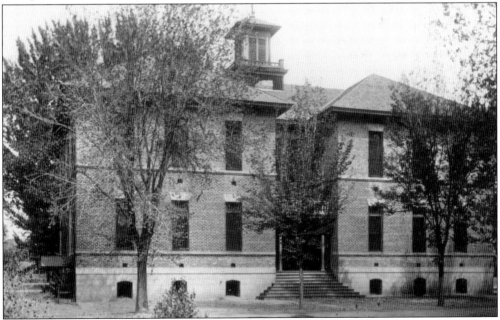

Hanford North School, built in 1908, marked the beginning of decentralization for Hanford schools. It was located on east Cameron Street between Douty and Harris Streets near where Earl F. Johnson School stands today. Replaced by the first Washington School (which became Earl K. Johnson), the building shown was razed in 1932. (Courtesy Hanford Carnegie Museum.)

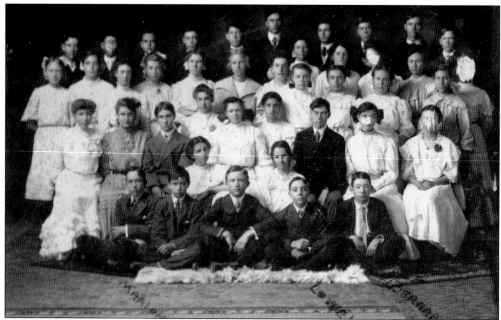

Here are Hanford (Central) Grammar School students photographed in 1907, the last year before decentralization. Included in the picture are Marlon Hall, Edward Gribi, Lowell Prough, Bernard Coe, ? Henderson, ? Diehl, ? Gribi, ? Rice, Ada Parrish, Nadine Hickman (Martin), Elizabeth Treadwell, Arthur Malmartron, Don ?, Frank Buckner, Marmon Childers, and ? Kennell. (Photograph donated by Claude Tinkle; courtesy Kings County Library.)

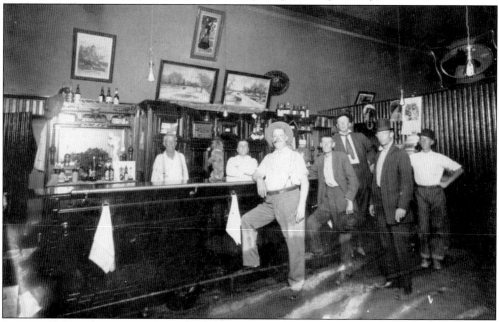

Despite all the civic improvements, the wild and wooly days of the 19th century were not quite over. Amos Elliot's Saloon on east Sixth Street was one of several dozen saloons in Hanford in 1902, when this photograph was taken. In 1912, the first year women could vote, saloons were outlawed within the city limits. (Courtesy Kings County Library.)

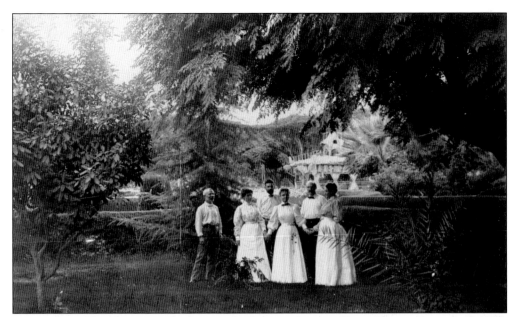

A more genteel gathering took place at the Lucerne home of Lew Chittenden around 1900. Chittenden was owner of the Lucerne Vineyard, the largest vineyard under single management in the world. The building in the background is a pool house, and Chittenden would often invite guests over for swim parties. (Courtesy Kings County Museum.)

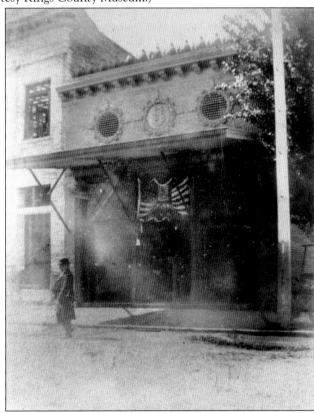

The "old" post office was located at 112 West Seventh Street, c. 1900. A second post office, since replaced by the current post office building, replaced this one in 1916 (see page 27, bottom) and still stands today. (Courtesy Hanford Carnegie Museum.)

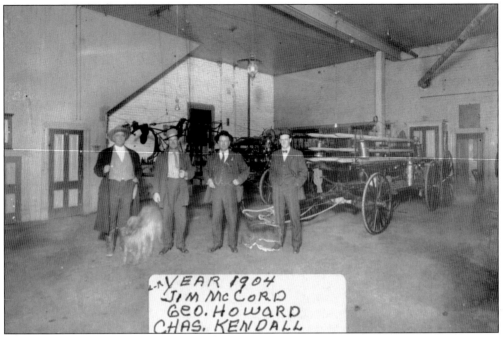

The interior of the Hanford Firehouse was photographed about 1904. Shown in front of the first fire wagon from left to right are Jim McCord, George T. Howard (who built the wagon), Charles Kendall (fire chief), and Perry Gard. The dog is unidentified. (Courtesy of Kings County Museum.)

Hanford boasted its own successful composer during the Victorian Era. Charles W. Barrett was moderately successful with songs like "The Mosquito" (left) and "A Giddy Bright Star Winked at Me." The former song was inspired by Barrett's experiences with the ever-present mosquitoes along the sloughs in and around Hanford. (Courtesy Library of Congress.)

18

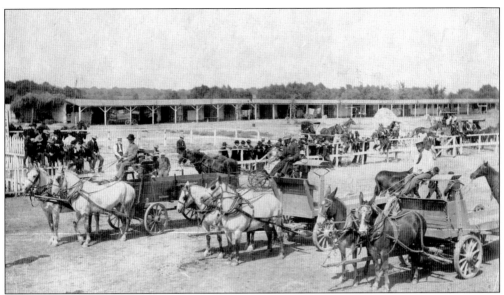

In 1904, the Kings County Fair was held at the Kings County Hospital grounds, where it remained for a number of years. Later the Kings County Honor Farm, a low-security part of the prison system, was located at this site after the hospital moved to a new location. (Courtesy Kings County Museum.)

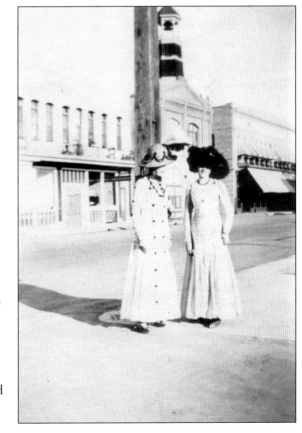

Mabel Corigan (left) and Maude Montgomery went out for a Sunday stroll in 1905. Standing in front of the old post office (see page 17, bottom) on Douty Street with the firehouse in the background, they were photographed in their Sunday best by Maude's husband, Robert, using a new, 1905 Kodak camera he purchased from Rainey's Drug store. (Courtesy Hanford Carnegie Museum.)

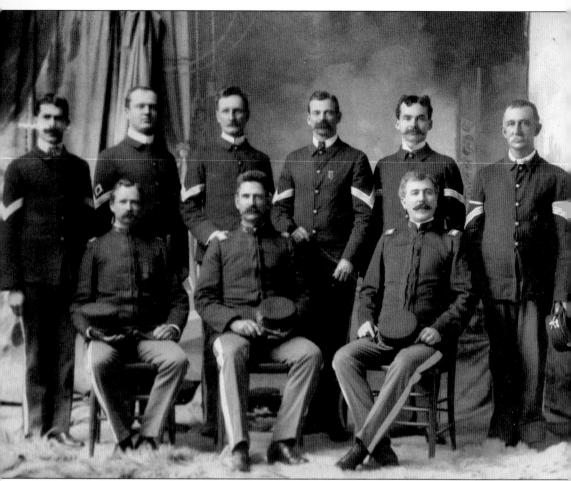

Members of Company I, 6th Infantry of the California National Guard posed for this portrait. From left to right are (first row) Capt. P. M. Norboe, 1st Lt. W. V. Buckner, and 2nd Lt. B. B. McGinnis; (second row) Sgt. Roy Vuckovich, Sgt. Earl Ayers, Sgt. Lord Wynne, Sgt. Andy Ayer, Sgt. Frank Hickman, and Q.M. Sgt. Ed Reuck. (Photograph by Powell Studios; donated by Roy Vuckovich; courtesy Kings County Museum.)

Two

HOMETOWN AMERICA
1910–1919

Walter W. Cameron organized a 50-mile automobile race around Hanford in 1913. Cars were still relatively novel in 1913, but widespread interest in them led to explosive growth. As the dust cloud behind the race car shows, the roads were still dirt and not always suitable for automobiles or the humans who had to share the road with them. Within two years, the problem was so acute that the voters passed a bond for a system of paved roads throughout the county. (Courtesy Hanford Carnegie Museum.)

A ground-breaking ceremony was held for the Kings County highway system after the passage of a bond issue in 1915. Supervisor James McClellan wields the shovel. To his immediate left are the highway commissioners: C. C. Spinks of Hanford, chairman; J. A. Moore of Lemoore; and Frank M. Frazer of Lakeside. (Courtesy Kings County Library.)

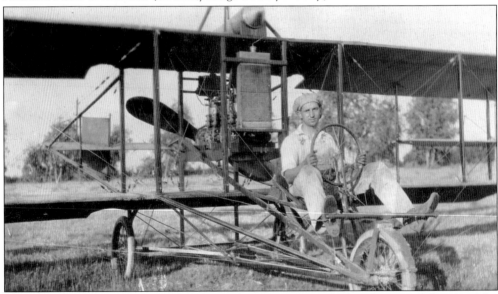

The automobile was not the only new machine to impact Hanford in the second decade of the century. Fred Funchess is shown about 1915 at the controls of an airplane he built himself. He developed an expandable piston ring that General Motors was interested in, but he died in an automobile accident in 1937 before he could sell the rights. He owned a mechanic shop on Douty Street. (Courtesy Kings County Museum.)

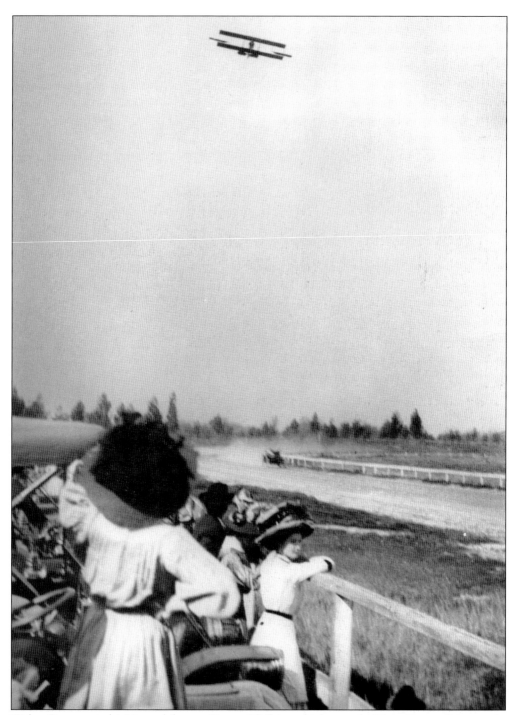

Walter Cameron in his Hupmobile races Eugene Ely flying a biplane at the Kings County Fairgrounds. Ely was reportedly the first man to land a plane on a battleship on January 18, 1911, foreshadowing the carrier landings of the planes flying out of Lemoore Naval Air Station just a few miles away and many years in the future. Roy Newport took this photograph in 1910. (Courtesy Kings County Museum.)

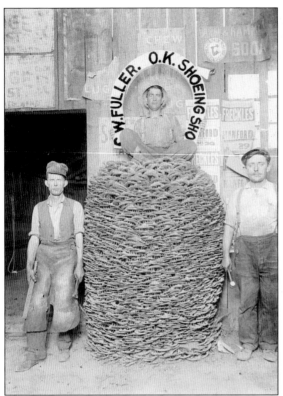

Not everyone was enamored with the airplane, however. Charles W. Fuller (right), the first child born in Hanford, on March 21, 1875, was a Hanford city councilman for 20 years and vigorously opposed the city's involvement in building an airport (see page 48, bottom). He is pictured around 1910 in front of his blacksmith shop. (Courtesy Kings County Museum.)

Cuff Burrell of Hanford was named the "World Champion All-Around Cowboy" at the 1919 Chicago World's Fair. He is pictured about 1918 with his traveling rodeo show companions at the old Hanford fairgrounds. Photographed from left to right are (first row) Charlie Reasons and ? Linville; (second row) J. Johnson, Cuff Burrell, H. Waite, Clayton Belcher, and B. Johnson; (third row) John Waite, Art Blackwell, George Chase, and Charlie Westcott. (Courtesy Kings County Museum.)

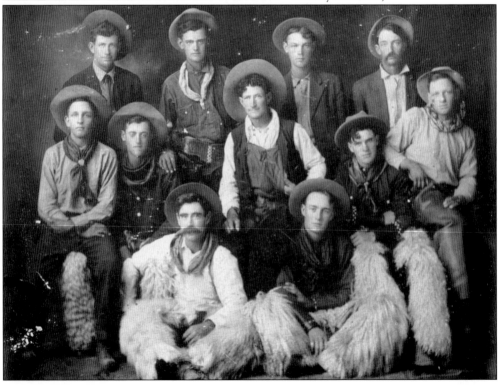

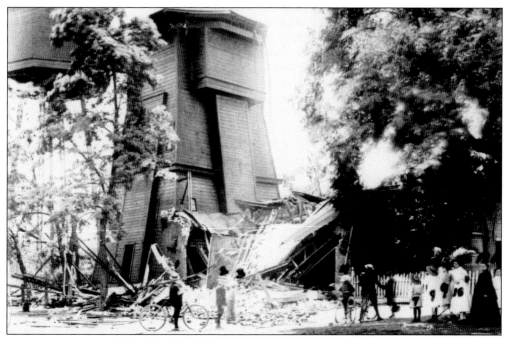

A sign of continuing growth, the old Hanford Water Works water tower at Irwin and Fifth Streets was demolished in 1910 to make way for newer, larger facilities (see page 38, bottom). (Courtesy of Kings County Library.)

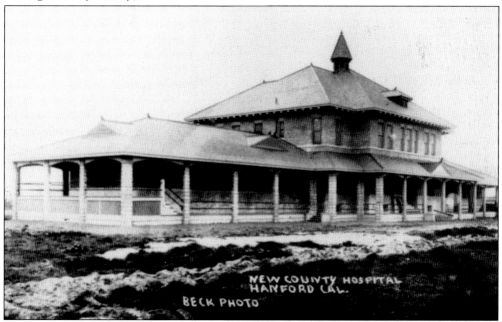

The "new" Kings County Hospital, replacing the old Hanford Sanitarium, is shown as it neared completion in 1910. It was located on Lacey Boulevard and later remodeled in 1936. A nursing school was added October 9, 1911. The building was used as a hospital until 1973 (see page 101, bottom), and portions of it remain in use today as government offices. (Courtesy Kings County Library.)

In 1911, Art Brunnell operated one of the first gas stations in Hanford at the southwest corner of Seventh Street and Tenth Avenue. Apparently the gas was delivered in a money-saving, horse-drawn wagon. (Courtesy Kings County Museum.)

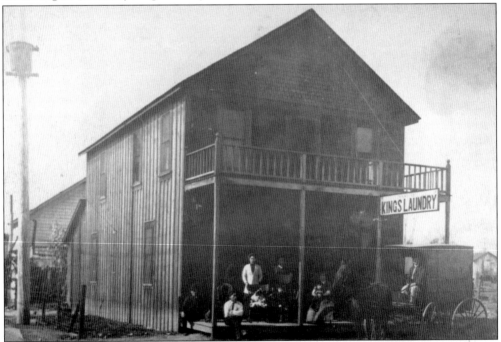

Hanford's longest continuously operating, family-owned business is Kings Hand Laundry, pictured shortly after it opened in 1910. Members of the Tagawa family stand out front. The laundry is still located in the same building at the same location on Green Street across from China Alley. New customers are no longer accepted. (Courtesy Naomi Tagawa.)

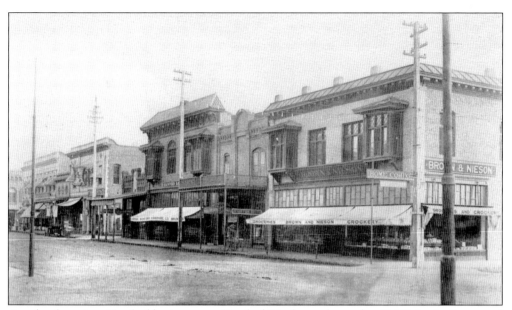

Another longtime Hanford business was Hanford Hardware, located at 216 N. Irwin Street and pictured in 1917. Next door is the Brown and Nieson building, whose owners were originally partners with Arthur Hammond in Hanford Hardware. In 1930, Herbert M. Works acquired a share in the business that remained in business at the same location until 1964. The Workingman's store is at that location now. (Courtesy Hanford Carnegie Museum.)

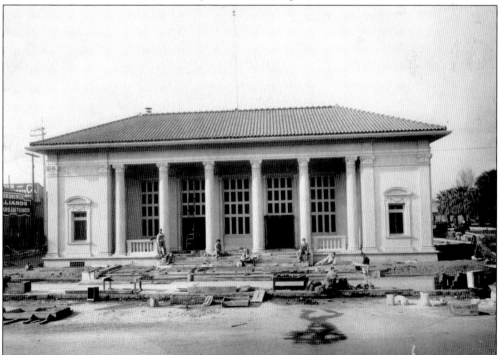

In 1914, a new post office building was built on Douty and Eighth Streets. Jim Stewart (foreman) stands on the left side of the steps, and James Gallagher Jr. of San Francisco (superintendent) sits on the right side of the steps. (Courtesy Kings County Library.)

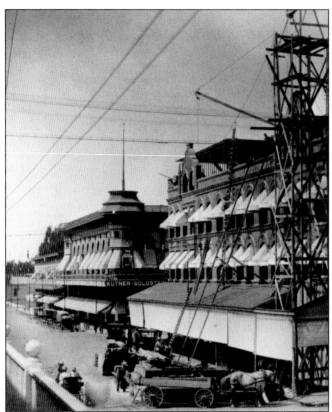

In 1914, the landmark Opera House Hotel added a wooden fourth floor. That construction is shown. In the background can be seen the Kutner-Goldstein building. To the right is a portion of the Artesia Hotel. Both the opera house's fourth floor and the Kutner-Goldstein building burned in 1928 (see page 43, bottom). The view is north along Irwin Street. (Courtesy Hanford Carnegie Museum.)

On May 23–27, 1911, the Kings Kounty Karnival celebrated the 20th anniversary of the formation of Kings County. Elected king was John Beck and queen was Florence Dodge. (Courtesy Ruth Gomes Collection, Kings County Library.)

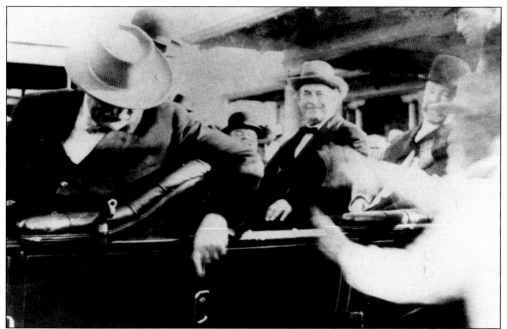

National political leader William Jennings Bryan is shown at the Southern Pacific Railroad station during a visit to Hanford about 1910. He was the political champion of the farmer and popular in the former Mussel Slough country, where the historic Mussel Slough Tragedy—a deadly confrontation in 1880 between settlers and the Southern Pacific Railroad—was still a recent memory. (Courtesy Kings County Library.)

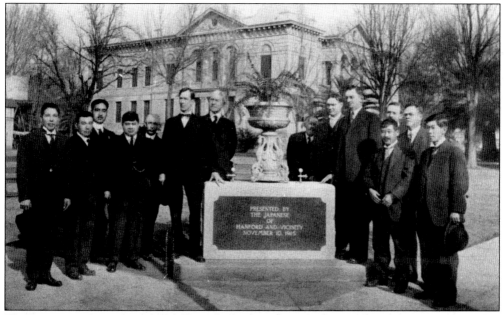

The Japanese citizens of Hanford dedicated a drinking fountain in Courthouse Square on November 10, 1915. The fountain was located at the corner of Douty and Eighth Streets. It was later moved down Eighth Street to the corner of Irwin and Eighth Streets (see page 78, top). (Courtesy Ruth Gomes Collection, Kings County Library.)

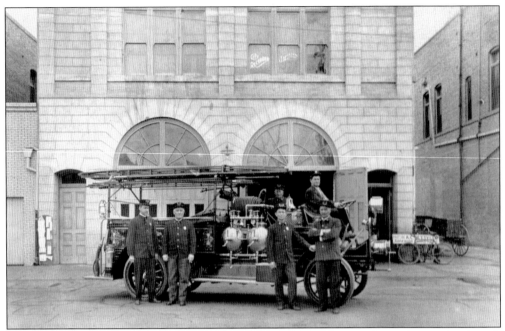

The Hanford Fire Department in 1911 is pictured with their first motor-driven fire truck, a brand-new 1911 Seagrave. From left to right are (first row) unidentified, Alvin M. Fredericks, Frank O'Brien, and Charles Kendall (chief); (second row) Jack Dold, ? Widemeir, and George Howard (driver). (Courtesy Kings County Library.)

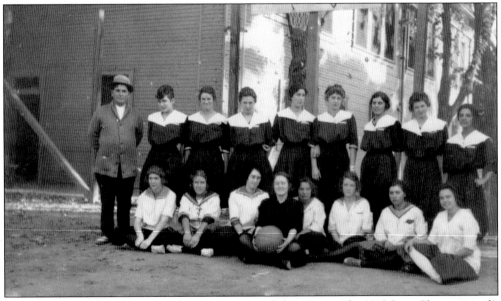

Among Hanford High School's earliest sports accomplishments was the 1915 State Champion girl's basketball team. Pictured outside the Lacey Park Campus, the championship team (second row) is posed under a basket that can be seen just at the top of the image. This photograph was found in a copy of the 1915 Hanford High School yearbook, the *Janus*, and is a different photograph than that chosen for inclusion in the yearbook. The first row is probably the junior varsity team. (Courtesy Hanford Carnegie Museum.)

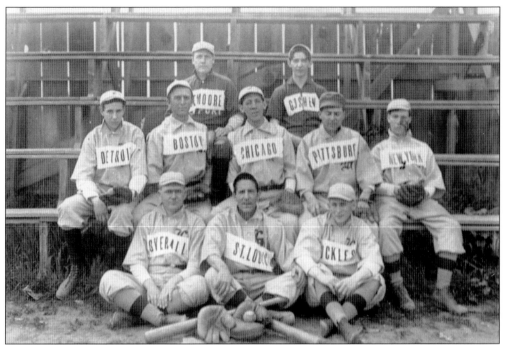

Employees of the Hanford newspapers formed the Hanford Printers baseball team. Pictured in 1910 are, from left to right, (first row), Arch Driver (owner, Hanford *Journal*), ? Gardner, and Billy Allen; (second row), Myron Tuttle (Hanford *Journal*), George Hull, Larry Smith (Hanford *Journal*), Fred Dewey (Hanford *Journal*), and Mark Pilkington; (third row), T. G. Manning and Archie J. MacKey. (Courtesy Kings County Museum.)

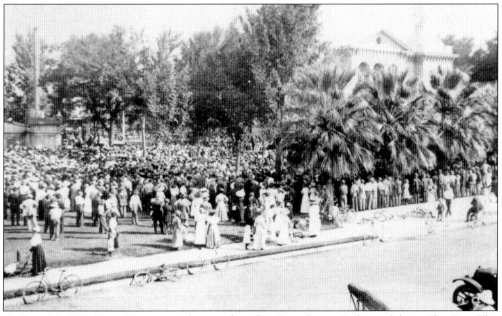

On June 14, 1917, Kings County residents gathered in Courthouse Park to celebrate Flag Day. The large turnout was due to the entrance of the United States into World War I just two months earlier. (Courtesy Ruth Gomes Collection, Kings County Library.)

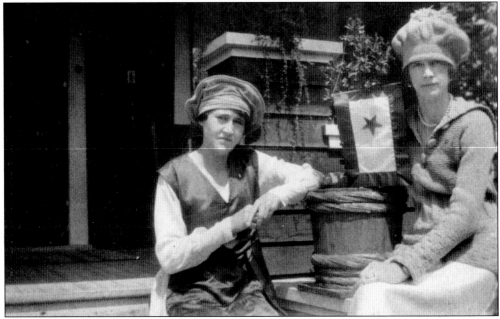

The second decade of the century ended with the world at war. Pictured September 8, 1918, the flag in the photograph indicates that the family had one member on active war service, in this case, "Brother Clinton Corey in service 1916 to 1919 in Europe." On the left is Maybelle Corey; the woman on the right is unidentified. (Courtesy Hanford Carnegie Museum.)

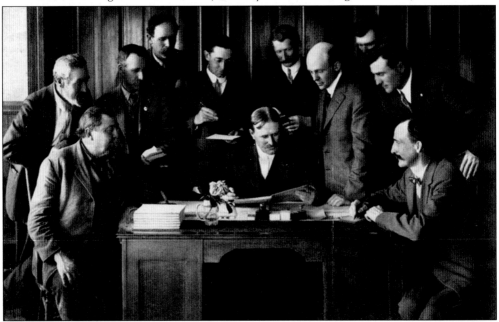

A little-known incident of not-so-little proportions occurred in 1914. Hanford was the center of a typhoid epidemic of sufficient severity to prompt Wilbur Sawyer, director of the State Hygienic Laboratory in Berkeley, to accompany the state "Clean-up Squad," shown above, to Hanford. The squad was successful, and this photograph taken April 16 celebrates that success. (Courtesy National Library of Medicine.)

Three

THE ROARING TWENTIES
1920–1929

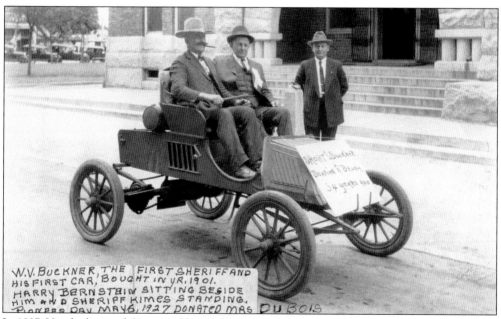

W.V. BUCKNER, THE FIRST SHERIFF AND HIS FIRST CAR, BOUGHT IN YR. 1901. HARRY BERNSTEIN SITTING BESIDE HIM AND SHERIFF KIMES STANDING. PIONEER DAY MAY 6, 1927 DONATED MRS DUBOIS

In 1927, Hanford turned 50 years old, and the town celebrated with a series of events culminating in the Pioneer Days Parade on May 6, 1927. It was the forerunner of today's Kings County Homecoming Days celebration. Pictured above is former sheriff William Van Buckner, the first Kings County sheriff driving the first sheriff's car in California (see page 13, top). Sitting beside him is Harry Bernstein, and then-sheriff Kimes is standing in the background. The sheriff's office and jail is behind him. (Photograph by Amos DuBois; courtesy Kings County Museum.)

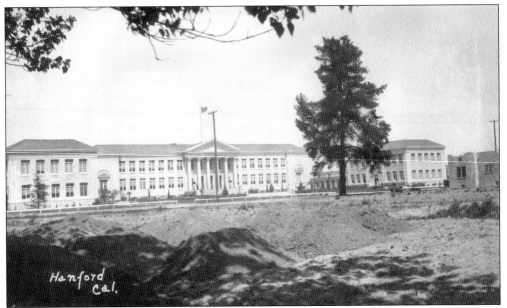

In 1921, a new Hanford High School campus on Grangeville was opened. The main building shown was later torn down (see page 100, bottom) and replaced on the same location by the current high school building. At the time, many criticized the decision to move the campus, as the *Sentinel* put it, "way out in the country." The growth of the town has since proved the wisdom of that decision. (Courtesy Kings County Library.)

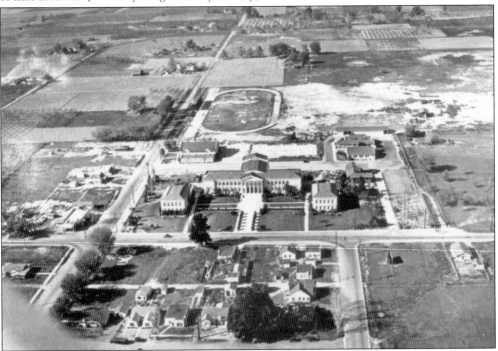

This aerial view of the new high school campus looks north a few years after the campus opened. Note that the track and football field in the photograph is not Neighbor Field. (Photograph donated by Jack Stone; courtesy Kings County Library.)

This rare action photograph shows a Hanford High School football game played at the old stadium. The image is dark both because it was late in the afternoon and because the camera had to use a fast shutter speed in order to capture the action. The crowd watching the game can be seen sitting in the old bleachers on the left side of the photograph. (Courtesy Hanford Carnegie Museum.)

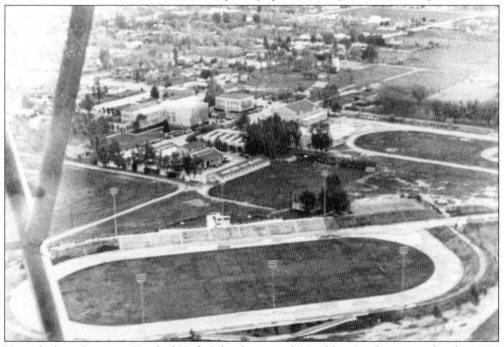

Named after a longtime Hanford High School principal, Neighbor Bowl was completed in 1935 but is included here for comparison. The old field can be seen just above the new field. Today the location of that old field is under Earl F. Johnson School. In fact, when EFJ was built, the construction crews had to remove old concrete pilings upon which the original stands stood. (Courtesy Kings County Library.)

Jim and Lois Peden opened Peden's Café on Seventh Street in 1922. From there, it moved to Big John's Food King at Eleventh and Grangeville Avenues and then to 210 W. Lacey Street behind the Fox Theater. It closed permanently in the late 1990s after three generations of Pedens had worked there. The family also owned the old Peter Pan Candy store on Seventh Street. (Courtesy Ruth Gomes Collection, Kings County Library.)

Rubalacava's Bakery on East Lacey Boulevard was started by the Rubalacava family in 1920. Originally located at 615 W. Seventh Street in a small frame house, the business expanded to include a restaurant that eventually became a Hanford landmark. The family remained in business at this location until the 1990s. (Courtesy Ruth Gomes Collection, Kings County Library.)

Freeman Richardson co-owned the Hanford Laundry on Seventh Street next to the railroad tracks. Already 25 years old, the business moved to this new $120,000 state-of-the-art dry cleaning plant in 1921. It featured pick-up and delivery service. The building was later renovated and houses numerous businesses today. (Courtesy Hanford Carnegie Library.)

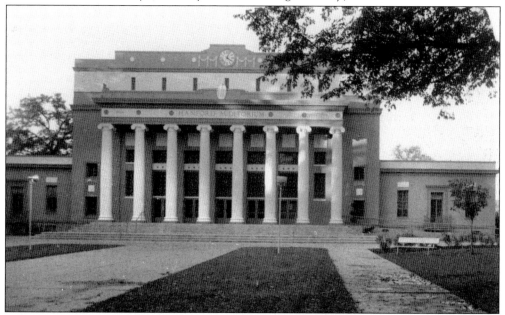

Dedicated on May 22, 1925, the civic auditorium cost $217, 948.91 and housed the Hanford city offices and the police department. The clock mounted above the entrance was originally installed in the Hanford Central School, which formerly stood at that location. Although not present at the dedication as has sometimes been claimed, John Phillip Sousa did present concerts in the auditorium in 1926 and 1928 (see page 68, bottom). (Courtesy Kings County Museum.)

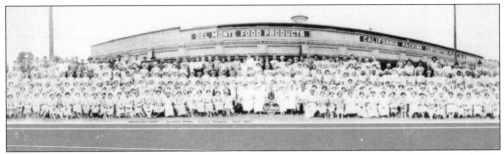

Shown in 1921, the Del Monte Food Products California Packing Plant No. 18 was a welcome addition to the Hanford economy, particularly during the Depression years. The plant continued to operate until the 1980s, when it was abandoned and later demolished (see page 120, top). (Photograph provided by Amelia Koening; courtesy Kings County Library.)

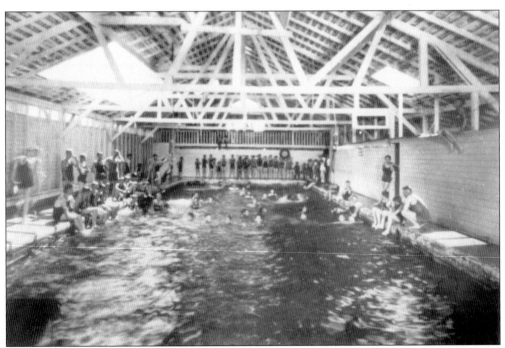

Called "the natatorium," this auxiliary firefighting water tank located at the corner of Irwin and Fifth Streets was owned by the Hanford Water Company. It was made available to the citizens of Hanford as a swimming pool. Whenever a fire broke out, a whistle blew, and swimmers knew to get out before the water was drained to fight the fire. (Courtesy Kings County Library.)

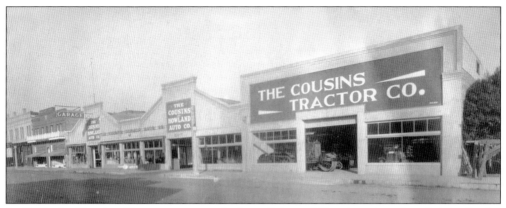

In 1920, the Cousins Tractor store stood where Salmons' Furniture is today. Originally the Imperial Garage in 1908, it was the Cousins and Howland Auto Company before becoming the Cousins Tractor Company. Later W. Ernie Davies bought it and renamed it the Davies Machinery Company. According to longtime employee Evan R. Nash, the tractor seen in the window is a C. L. Best No. 75. (Photograph by Powell Studios; courtesy Kings County Library.)

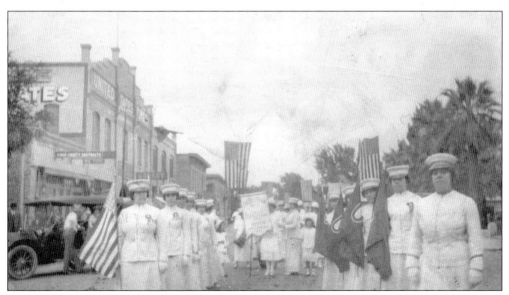

Pictured is the Hanford American Legion Women's Auxiliary Drill Team c. 1925. Looking west on Eighth Street during an Armistice Day parade, the buildings on left side include Kings County Abstracts and the United States Tire Company; to the right is Courthouse Square. Note that the flags have 48 stars. (Courtesy Katen/Salles family collection.)

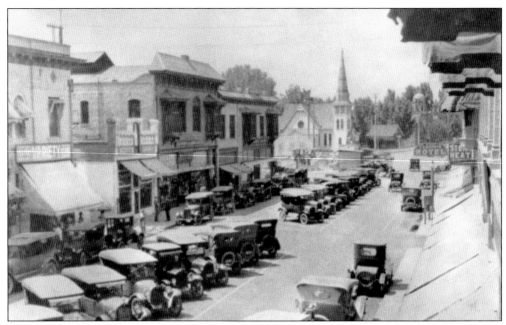

As this 1926 view of the 200 block of Irwin Street between Seventh and Eighth Streets suggests, the introduction of the automobile to Hanford was successful. Looking north, the Vendome building is on right, Hanford Hardware is on the left, and the old Presbyterian Church is in the center background. (Photograph by Hanford Sentinel; courtesy Hanford Carnegie Museum.)

There was one car for every six people (totaling 4,039) in Kings County by February 1923. As the number of cars increased, so did the traffic problems. A new law enforcement job was created by the automobile: the motorcycle cop. Kings County speed officer Arthur W. Benton is shown in 1922 astride his motorcycle with stopwatch in hand ready to enforce the already necessary traffic laws. (Courtesy Kings County Museum.)

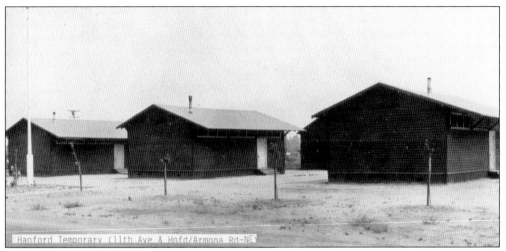

Hanford Temporary or South West School was located at the northeast corner of Eleventh Avenue and Hanford-Armona Road. It was purchased in 1921 to relieve overcrowding at South West School and paid for by a 1919 bond passed with an astounding 93 percent of the vote. South West School became Roosevelt School in 1935 and was replaced by the present Roosevelt School on West Davis Street in 1952. (Courtesy Hanford Carnegie Museum.)

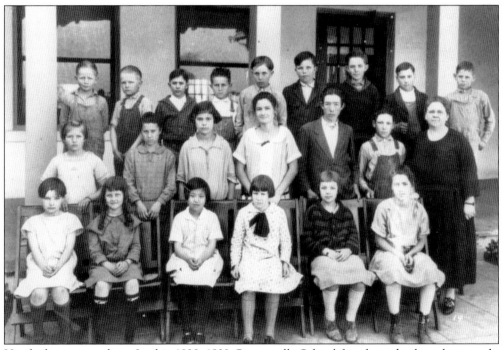

Hanford roots run deep: In this 1928–1929 Grangeville School fourth-grade class photograph, future Kings County supervisor Evon Cody can be seen fourth from the right in the third row. Kee Hase, third from the left in the first row, is the sister of Maki Hase, who served on the Pioneer School Board in the 1960s, 1970s, and 1980s. The schoolteacher is Mrs. Jenkinson. (Courtesy Kings County Museum.)

Rodeo clowns perform at the Hanford Rodeo November 11, 1923. Louis Lindley of Hanford wanted to be a rodeo star, but Cuff Burrell is said to have told him that the "pickin's would be slim" for him in rodeo and to try something else. So Lindley adopted the name "Slim Pickens" and became a rodeo clown. He was later to become famous as an actor. (Courtesy Kings County Library.)

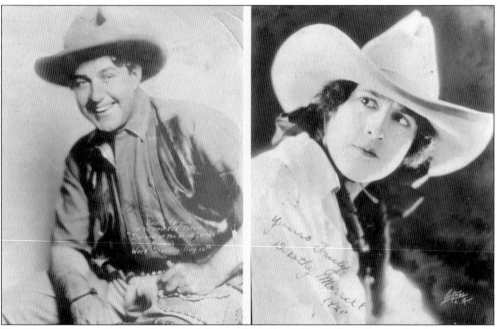

The Roaring Twenties were the era of the cowboy films. Pictured are Dustin Farnum, an early cowboy movie star (Cecil B. DeMille's first big star), and Dorothy Morrell, the California girl who was the World Champion Cowgirl Bronc Rider during the 1914 Pendelton Roundup. Morrell was later a rodeo friend of Cuff Burrell's who went on to become a movie star. (Courtesy Hanford Carnegie Museum.)

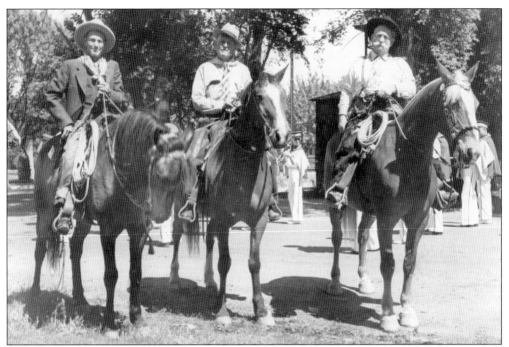

Emmett Ford, Clint Daggs, and Lavoy Landis ride again at the 1927 Pioneer Days festivities celebrating Hanford's 50th anniversary. The three cowboys appeared in the first Hanford book on page 95 and were prominent characters in the early days of the town. Lavoy Landis later served as sheriff of Lemoore, and his extensive collection of early photographs was donated to the Kings County Museum. (Courtesy Kings County Museum.)

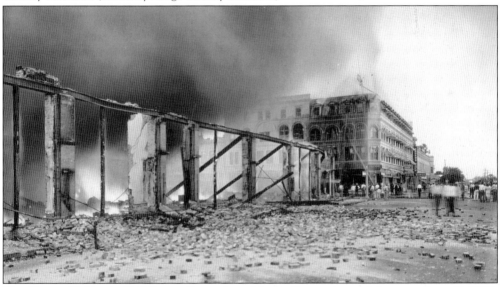

The Kutner-Goldstein Building at Seventh and Irwin Streets burned down on June 17, 1928, destroying the fourth floor of the Kings Hotel (old Opera House) across the street and breaking every window in the First National Bank next door. G. M. Eaglin, the store's night watchman, was burned on the neck and arm escaping the building, and Frank O'Brien, a fire truck driver, was slightly burned on the arm (Courtesy Kings County Museum.)

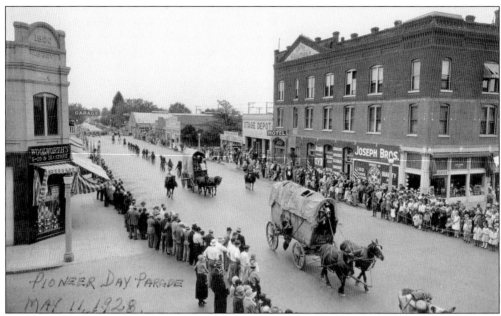

Hanford celebrated the 1928 Pioneer Days with a parade shown moving west on Seventh Street near Douty Street. The Pioneer Days celebration was the forerunner of today's Kings County Homecoming Days. In front is the original Brooks wagon that appeared in every homecoming parade until the late 1970s, when it was replaced by an exact replica. The original is now on display at the Burris Park Museum. (Courtesy Kings County Museum.)

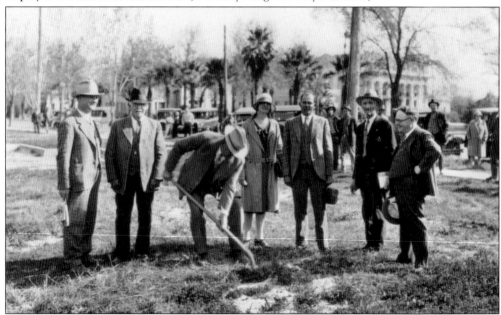

The ground-breaking ceremony for the Fox Theater was held in April 1929. By the time the theater was ready to open, Black Friday had occurred, and the Great Depression brought the Roaring Twenties to an abrupt halt. Shown from left to right are unidentified, Charles Coe, Mayor Jim Wilson, Effie Warnock, unidentified, A. E. Ade, and unidentified. (Courtesy Kings County Library.)

Four

THE DEPRESSION YEARS
1930–1939

The Fox Theater is pictured just prior to opening day December 24, 1930. Operated by West Coast Theaters, the $250,000 cost would be difficult to recoup, but Hanford residents welcomed the chance to forget about the Depression in the theater's impressive interior. The theater remains in use today, restored to its original glory by the Humason family, Dan, Wilma and Danny, who restored it in the 1980s. (Courtesy Kings County Library.)

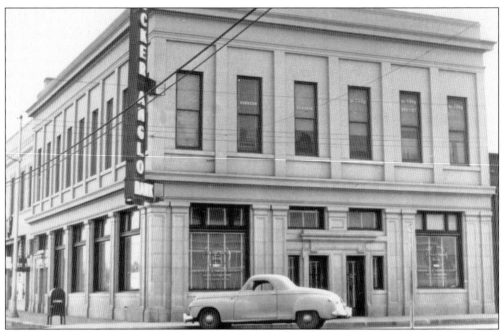

The Crocker-Angelo Bank, located in the old First National Bank building at the corner of Irwin and Seventh Streets, survived the stock market crash of October 1929, which plunged the nation into the Depression. Within a few months, depositors lost $140 billion. Ten thousand banks across the nation failed, and one-third of Americans fell below the poverty line. It was not the best of times. (Courtesy Kings County Library.)

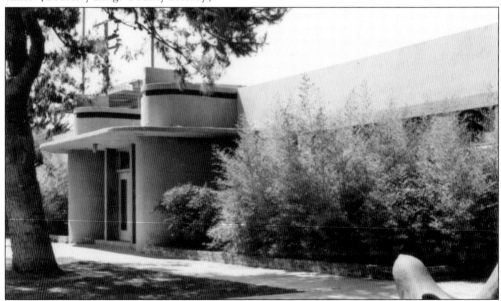

The municipal swimming pool was a WPA project constructed in conjunction with a new fire station during 1938–1939. Known as "the plunge," the pool was used until 1985, when it was shut down. It was abandoned in 1989 and later demolished. It was replaced with newer facilities in the 1990s. Clara Holland supervised original lifeguards Carl Eller Jr. and Jimmy Proudfoot. (Photograph by Alice Stevenson; courtesy Kings County Library.)

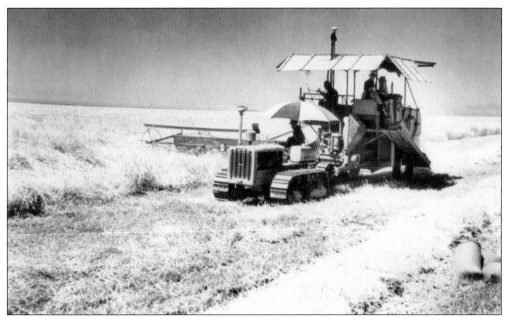

Despite the Depression, farm life continued. Grain fields had to be harvested, and new mechanized equipment made the task more efficient. A caterpillar tractor pulling a Holt combine, like the one shown above, was capable of harvesting four and a half acres of grain per hour. Gas-driven engines were lighter and more reliable than their older steam counterparts. (Courtesy Kings County Museum.)

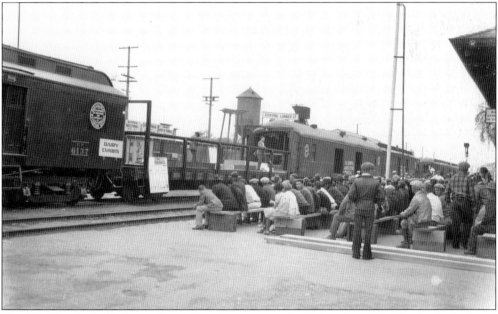

The "California Agricultural Special" train was part of a University of California Agricultural Extension Services program that aimed to educate farmers about the newest farming techniques. It featured agricultural exhibits and a dairy products speaker. Government-sponsored programs like this were gradually helping pull the country out of the Depression, but it took World War II to end it. (Courtesy Kings County Library.)

The San Joaquin Nursery, owned by Roy Takeda, was a state-licensed landscaper since 1905. It was located on E. Seventh Street near China Alley. The nursery continued at the same location, but under different owners, until the 1990s. Today Kings County Mobile Glass uses the old nursery facilities. (Photograph donated by Michi Takeda; courtesy Kings County Library.)

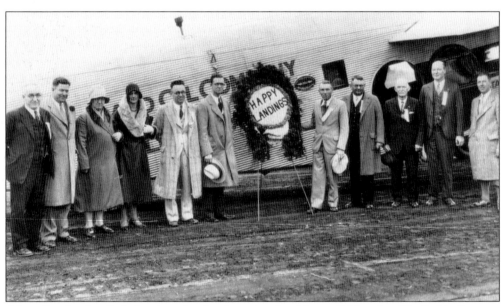

After a female pilot died when her plane's exhaust set the old grass field on fire, Hanford built a new airport dedicated November 15, 1930. It was located on Tenth Avenue where the fairgrounds are today. Photographed from left to right are Dan Cackler, two unidentified people, Effie Warnock, Laurence Short, unidentified, Ray Newport, Jim Wilson, Charles Coe, Roy Hayes, and unidentified. The present-day airport was built after World War II. (Courtesy Kings County Library.)

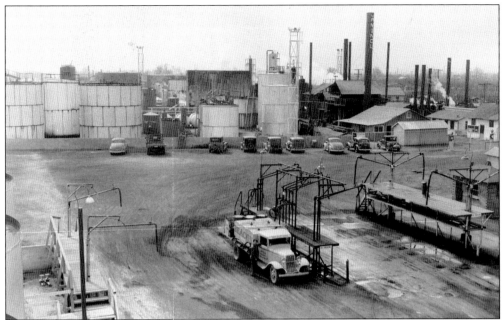

Purchased from the Kettleman Hills Gasoline Company in 1931, the Caminol Oil Company was formed by Walter Allen and processed lightweight crude oil from the Kettleman Hills oil fields. It later became the Beacon Oil Company and the largest independent refiner and distributor of gasoline in the state. The town welcomed the company, as it provided many local jobs during the Depression years. (Courtesy Kings County Library.)

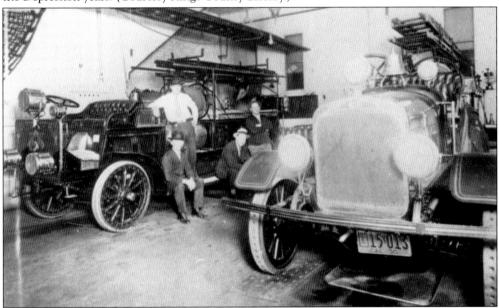

From left to right, Frank O'Brien, Fire Chief Sherman D. Logan, Arthur LeCavalier, and Herbert Worley pose on the 1911 Seagrave fire truck inside the Douty Street firehouse in 1930 (see page 30, top). The Seagrave was last used at the 1942 J. C. Penney fire (page 66, top) and driven by Cecil Shelton. It was retired in 1944 and donated to the Burris Park Museum on September 26, 1950. (Courtesy Kings County Library.)

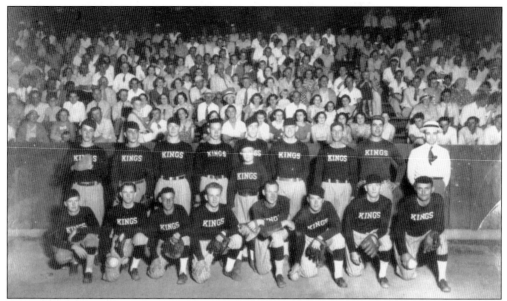

Members of the 1935 Hanford Kings softball team pose with their fans. Shown, from left to right, are (first row) Russ Cadwell, Harry Bec, Johnnie Norton, Max Hoff, Mam Mora, Rae Mackey, Lee Rice, and manager Pete Filippi; (second row) bat boy Bruce Lewis; (third row) unidentified, Dave Webb, Lynn Stackler, Evert Webb, Bob Fowler, "Hop" Veires, Buck More, Bill Macedo, and Leo Togneri. (Photograph donated by Katie Filippi; courtesy Kings County Library.)

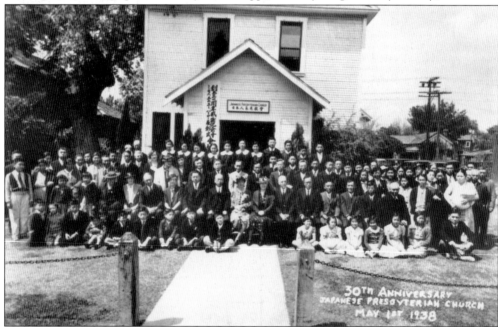

The Japanese Presbyterian Church celebrated its 30th anniversary on May 1, 1938. During the war, the church closed when all its members were sent to relocation camps. The church building was destroyed by fire shortly after the end of the war; only a few former members had returned to town when it happened. Famed artist Henry Sugimoto married Susie Tagawa here on April 24, 1931 (see page 86). (Courtesy Naomi Tagawa.)

The Hanford High School woodworking exhibit at the 1930 California State Fair was awarded the Sweepstakes and Feature Exhibit trophy. It was one of many such state and national awards, including the National Championship in 1951, won by the school under the direction of legendary Hanford High School wood shop teacher Fred Marcellus. (Courtesy Hanford Carnegie Museum.)

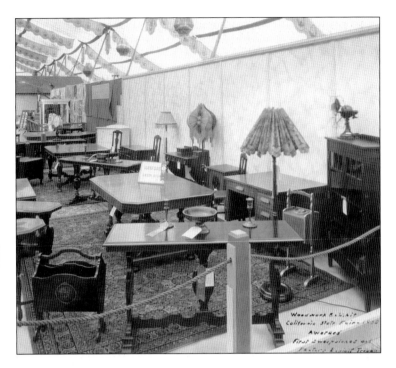

The 1930 Woodrow Wilson eighth-grade class shown from left to right are as follows: (first row) Melvin McCulloch, Wendell Bahler, Ted Misenheimer, Fred Abraham, Dick Tarr, Don Parsons, Yori TadaWada, Bill Messer, and Robert Rouse; (second row) Jean Horton, Claire Donahue, Ruth Milwee, Grace VanderVier, unidentified, Edna Mae Vickers, unidentified, Lorna Crabtree, and two unidentified; (third row) teacher Geraldine Haag, Shiro Omata, Leo Costa, Ben Didui, Constance Prusso, unidentified, Delores Vincent, unidentified, Seth Marchbanks, Bob Doherty, and Arthur Lopez; (fourth row) Robert Lopez, Jerome Salazar, John Worley, Dick Chatten, Paul Saylor, Cecil Shelton, and Joaquin Alvarez. (Courtesy Kings County Museum.)

Construction of Hamilton School, originally called East School, was completed in December 1930. Scheduled for demolition in 1953, the City of Hanford bought it then leased it back to the Hanford Elementary School District for administrative offices. The district later regained ownership and continues to use it as district offices. The playground was later sold to the Salvation Army. (Courtesy Kings County Library.)

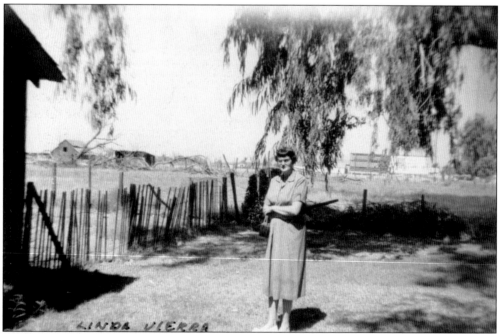

Linda Vierra is pictured on the family farm; looking north, this view shows the Joe Freitas family barn (the larger building in the left background), which is where the Hanford High School baseball and soccer fields are today. Both properties were taken by eminent domain for school use. The Old Sportsman's Club was where the billboard in the background is, and the white house just to its left still stands at that spot. (Courtesy Vierra family collection.)

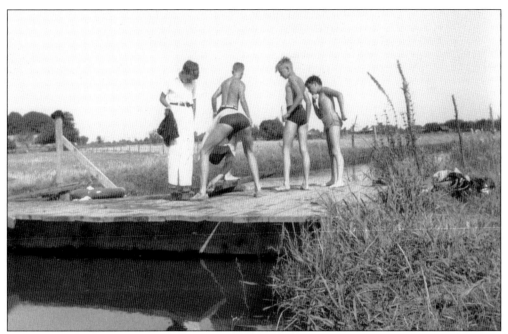

This 1938 photograph of boys swimming in Bowden's Ditch is an idyllic scene amidst the threat of war on the horizon and the ravages of the Depression. Included, in no particular order, are Ed Mincy, Gus Dieslin, John Walker ?, Warren Stine, and an unidentified friend; they are readying a homemade diving board for use. (Photograph by Paul Hill; courtesy Hanford Carnegie Museum.)

Shown somewhere between Bakersfield and Fresno on March 11, 1940, this 20-year-old hobo told the photographer that he was from Oakland and had been "hopping freight cars on the bum for two years." His father worked for the WPA, and his mother was a domestic. His married sister and her child lived with his parents in their crowded flat, and there was no room for him. (Courtesy National Archives.)

One of Hanford's greatest treasures is the Superior Dairy Restaurant, opened February 8, 1930, by F. J. Bowden, manager of the Lucerne Creamery. J. W. Bowden, the founder's son, grew up in a house where the library now stands and took over the store in 1961. Today Susan Bowden Wing and her brother Tim Jones own the store. (Photograph donated by Superior Dairy; courtesy Kings County Library.)

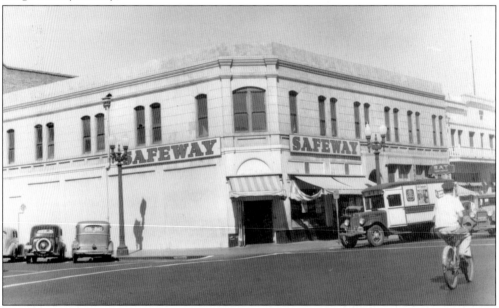

In 1929, Safeway stores learned that the Hanford-based Lucerne Cream and Butter Company was failing and purchased it to protect its butter supply. It was the start of the Safeway Dairy Division, now an international business. The old Lucerne plant was updated, and Safeway built two stores in Hanford, including the "downtown store," shown at the corner of Seventh and Douty Streets. (Photograph by Dave Rantz; courtesy Kings County Library.)

Hanford native Mary Packwood was a public schoolteacher in Fresno and a licensed pilot who owned her own plane. Mary kept her plane at the Fresno airport, where famed aviatrix Amelia Earhart was known to have landed a number of times. After an introduction by a mutual acquaintance in the fall of 1934, the two liberated women quickly became friends. (Photograph by Edward E. Bishop.)

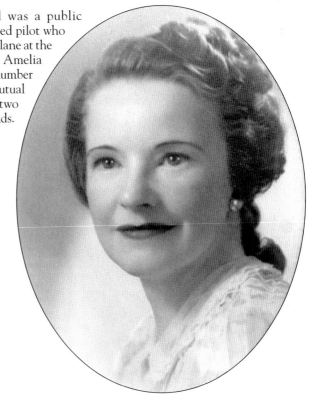

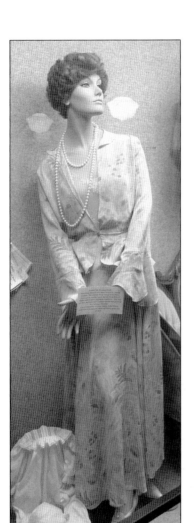

Amelia stayed at Mary's parents' home in Hanford on several occasions. During some of those visits, the two would go dancing. Always conscious of her appearance, Amelia left this dress at Mary's parents' house to use whenever she came to visit. After her disappearance, Mary called Amelia's family and asked if they wanted the dress; they told her to keep it as a souvenir. (Photograph by Edward E. Bishop.)

Amelia Earhart models a dress from her fashion house collection. She opened the fashion business in February 1934, just a few months before she met Mary Packwood. Amelia was an accomplished seamstress and had dreamed of owning her own fashion line. There is a chance that the dress in the Carnegie Museum (pictured on the previous page) is from Amelia's fashion house, even though it does not bear a fashion house label. After Amelia's disappearance, Mary took the dress apart intending to create one more her size. The dress was never finished and was packed away for a number of years. Later an expert local seamstress recreated the dress from the original plans and pieces. The dress is on exhibit in the Hanford Carnegie Museum. (Courtesy Charles P. Putnam Collection, Purdue University.)

Five

THE WAR YEARS
1940–1949

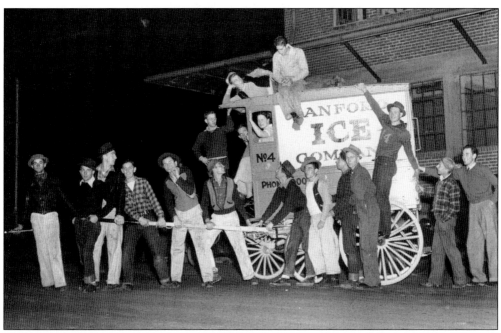

The worst of the Depression was over, and World War II not yet begun when this group of Hanford teenagers decided one night in 1940 to "borrow" one of the venerable Hanford Ice delivery wagons as a prank. They were intercepted by the local police and a *Sentinel* photographer who "caught 'em the act." The boys had to take the wagon back. The perpetrators will remain nameless, but a number of future city fathers can be recognized among them. This photograph is featured on the cover. (Courtesy Kings County Library.)

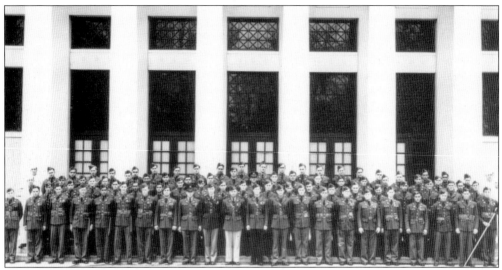

The Hanford National Guard, Company B, 185th Infantry Regiment, was among the first to be called to active duty after the December 7, 1941, attack on Pearl Harbor. Commanded by Capt. Lee Brown, the unit included future Kings County supervisor Dom Faruzzi (second row, fifth from left). It was part of the largest mobilization in American history. War had come to Hanford. (Courtesy Kings County Museum.)

The Barros family army, from left to right, was made up of Frank, Anthony, Joseph Jr., Wilma, and William. The war brought almost total mobilization of the American people toward the goal of defeating the Axis powers. Families dedicated to the war effort, such as the Barroses, were not unusual, although having five service persons from the same immediate family was noteworthy. (Photograph by Lila Barros; courtesy Kings County Library.)

The Tagawa family—owners of Kings Hand Laundry—also sacrificed, but involuntarily. They were sent to Jerome Relocation Center in Arkansas during the war. Naomi is pictured at the camp after it snowed. When she and her family returned after the war, they found that their Caucasian friends in Hanford had kept the family's belongings just as they had left them. Others were not so lucky. (Courtesy Naomi Tagawa.)

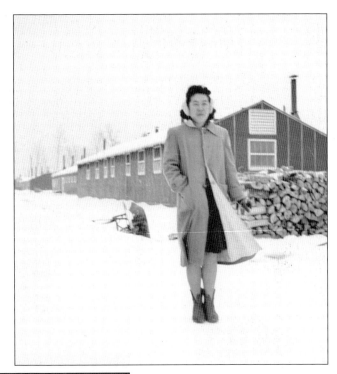

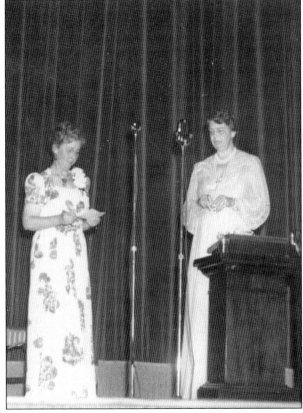

Introduced by Amy Hall, First Lady Eleanor Roosevelt visited Hanford on April 29, 1941. Her stop was part of a tour to promote the first scrap drive to support the nation's military assistance to Great Britain in the war against Nazi Germany. Hanford responded, perhaps too enthusiastically; the city fathers decided to donate the old, bronze fire bell from the historic fire department. (Courtesy Hanford Carnegie Museum.)

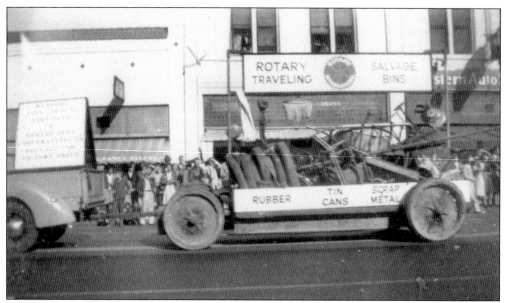

Those on the home front helped support the war by giving up rationed items, contributing to scrap drives, growing Victory Gardens, buying war bonds, and obeying curfews and travel restrictions. These restrictions on personal liberty and convenience were tolerated, even welcomed in some cases, as "doing one's part" to win the war. It is doubtful that they would be met with the same reaction today. (Courtesy Kings County Museum.)

In response to the first lady's call for help with the national scrap drive, the firehouse bell was lowered from its perch in the firehouse tower and placed on the scrap wagon. It made it to the scrap drive trailer, but it never made it to the scrap heap. It disappeared somewhere in between, a mystery that was only revealed after the war. (Photograph by Hanford *Sentinel*; courtesy Kings County Library.)

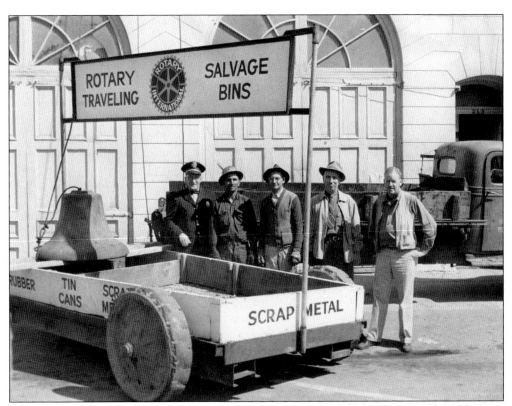

Some historic and civic-minded folks, hearing that the scrap yard owner was going to sell the bell to someone in Visalia, spirited the bell away during the night and stored it. It was later returned to the community and displayed in front of the old fire department. The identity of the saviors of the bell has remained a secret to the general public to this day. (Courtesy Kings County Library.)

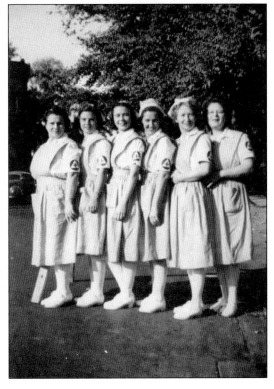

Pearl Harbor had left very little of the U.S. Navy to stand between the powerful Japanese naval forces and America's West Coast, and the fear of invasion was very real. Civil defense measures were instituted, and most everyone did their part. Pictured from left to right are Joy Hale, two unidentified women, Hazel Fowler, unidentified (with 2,000 hours volunteered), and Madeline Leoni, all of whom volunteered to become Red Cross nurse's aides in 1942. (Courtesy Kings County Library.)

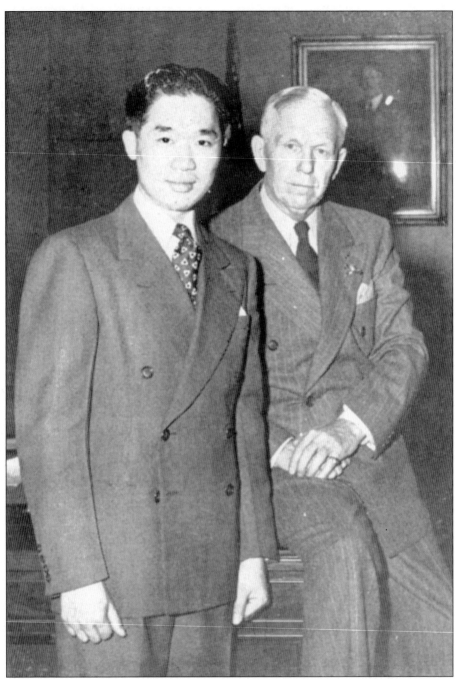

During the war, T. Sgt. Richard Wing served as the personal aide to Gen. George C. Marshal for almost three years and was his official food taster. Wing thus learned something about fine French foods, knowledge which he leveraged to start the world class Imperial Dynasty Restaurant after the war. The photograph above was taken in 1948 when Secretary of State Marshal visited the West Coast and invited Richard to be his guest. Wing flew from San Francisco to Los Angeles with Marshal on board the presidential plane, "The Scared Cow." (Photograph by Hanford *Sentinel*; courtesy Kings County Library.)

Many Japanese men chose to leave the relatively safe confines of the relocation camps to serve in combat. Theirs was a sacrifice of particular note in light of the treatment they had received. Shown in 1949, the Hanford Veterans of Foreign Wars Nisei Liberty Post No. 5869 included members of the famous 442nd Regimental Combat Team, the most decorated combat outfit of the war. (Photograph donated by Tom Asaki; courtesy Kings County Library.)

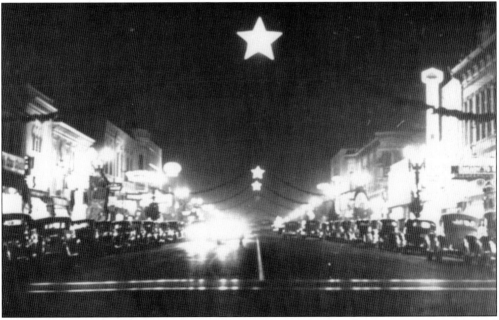

"When the lights go on (all over the world)" went the words of the hit wartime song performed by Vera Lynn and others. The war did end, and the lights did go on, including in Hanford. The long war was over, and, as the troops returned, everyone's mind turned to reestablishing normalcy. Hanford lit up downtown for Christmas 1945—as it has every year since. (Courtesy Kings County Library.)

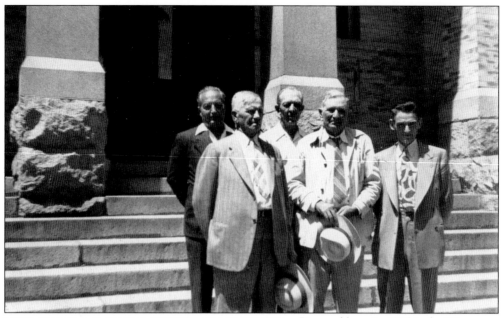

Pictured here in 1945 is the Kings County Board of Supervisors that led the county during the war years. From left to right are Robert Crain, Grant Garner, Chairman Russell Troutner, Jesse Hausere, and Berry Gilcrease. (Courtesy Kings County Library.)

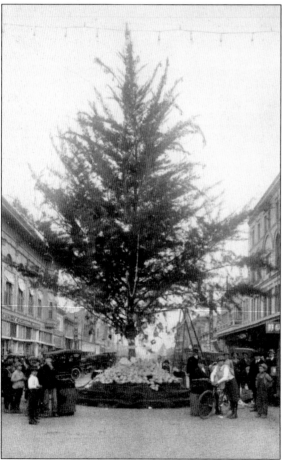

Christmas 1945 marked the first holiday of worldwide peace in almost a decade. Hanford displayed a municipal Christmas tree until the early 1980s, when the increasingly litigious society made it too risky to continue to do so. It seems America can lick the worst the world has to offer but not the irresponsibility of its own citizens. (Courtesy Ruth Gomes Collection, Kings County Library.)

These Hanford girls pose outside the J. C. Penney's store on Eighth Street sometime before the store burned down in 1942. Photographed from left to right are (first row) Lila Barros; (second row) Dorothy Williams (Huddleston), Wanda Huffman (Koelewyn), Betty Jo Willis, and JoAnn Ambrosini. (Courtesy Kings County Library.)

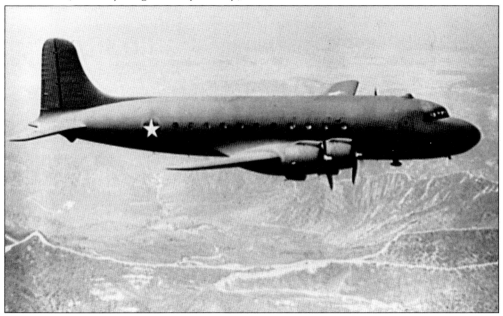

On November 4, 1944, a TWA DC-3 mysteriously crashed near the intersection of Fargo and 8½ Avenues. The plane was equipped with an early model flight recorder that helped aviation investigators determine that the plane had run into a thunderstorm going at too great a speed and was literally ripped apart. It was the first time that a flight recorder was used to determine the cause of an airplane crash. (Courtesy R. M. Roberts.)

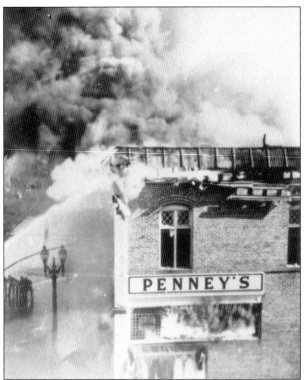

The J. C. Penney store at the corner of Irwin and Eighth Streets caught fire and burned down on May 31, 1942. It was the last fire at which the 1911 Seagrave fire truck was used (pages 30 and 60). Patrons recall that payments for merchandise were placed in little buckets, which were reeled to a cashier upstairs who made change and sent it back down. (Photograph by Lila Barros; courtesy Kings County Library.)

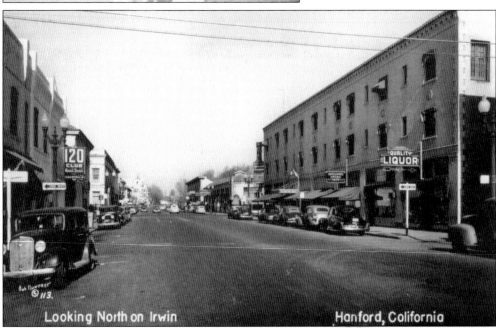

Looking North on Irwin **Hanford, California**

In this view of Irwin Street looking north from Sixth Street, the 120 Club, owned by John Scanlon, can be seen. On the opposite side of the street, Quality Liquor, Ratcliffe's Apparel Shop, and the Hotel Whilton are visible. The "One Way" signs on each side of the street refer to the alleyway that runs midway through the block between Sixth and Seventh Streets. (Courtesy Hanford Carnegie Museum.)

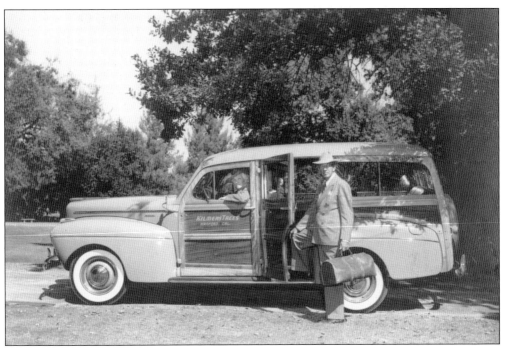

Mr. and Mrs. George Aydelott are shown in their "woody" station wagon in 1941. The couple owned a ranch named Kilmer's Trees about three miles north of Hanford. The Martin family later owned the property. This type of station wagon later became famous in the surfing movies of the 1960s. Station wagons are almost a thing of the past; today minivans fulfill the same purpose. (Courtesy Hanford Carnegie Museum.)

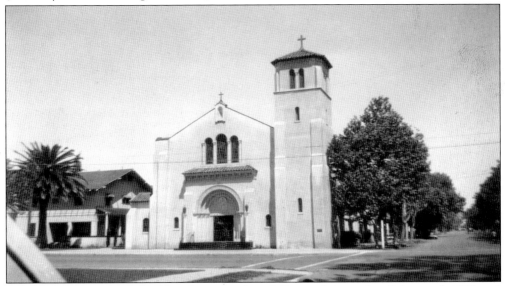

St. Brigid's Roman Catholic Church, pictured in 1948, was dedicated on February 5, 1928, and was built on the site of the original Our Lady of Guadalupe Church, now located on Second and Douty Streets. Among the many weddings performed here, one was for Rita Hayworth's brother Roberto Casino in 1944. He was stationed at Lemoore Army Airfield, and Miss Hayworth attended the wedding. (Courtesy Vierra family collection.)

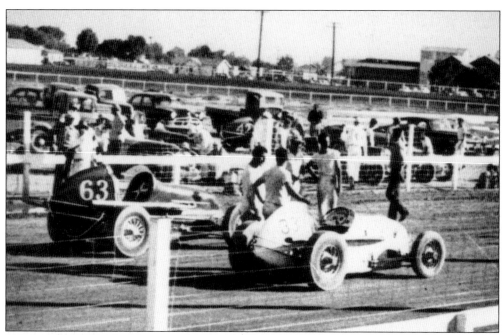

Taken in the 1940s, this photograph shows dirt track racing cars in action at the Kings Raceway on the county fairgrounds. During the war, racing was suspended because of gasoline and tire rationing, but it returned after the war. Local brothers John D. and Delbert E. Walker were heavily involved in the racing scene. Delbert was killed in a racing accident in Santa Rosa in the 1920s. (Courtesy Hanford Carnegie Museum.)

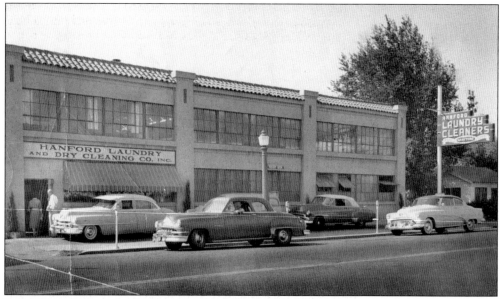

This is how the Laundry Building appeared during the 1940s. The sign out front advertises that the company uses "Sanitone," a patented dry cleaning process of the time. In addition to pick-up and delivery service, a drop box was supplied for after-hours deposits. The sign identifying its location can be seen just to the right of the lamppost near the center of the building (see also page 37, bottom). (Courtesy Hanford Carnegie Museum.)

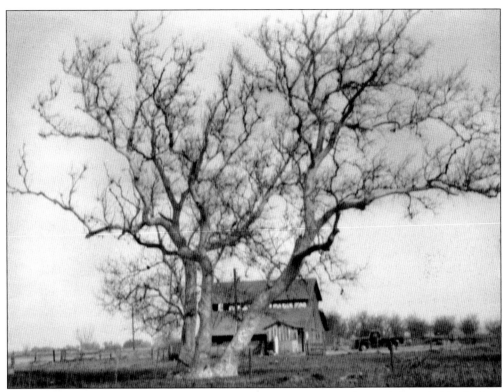

Pictured here is the famous Landmark Tree, an ancient Sycamore located about half mile from the Adobe de los Robles and a quarter mile west of Hanford-Armona Road. It is featured in M. M. Miller's book *First the Blade*. This photograph was taken during the 1940s, and information written at the time suggests that it was "the oldest tree in the county, outside of some river oaks." (Courtesy Hanford Carnegie Museum.)

Kings County sheriff Orvie Clyde greets California governor and future chief justice of the Supreme Court Earl Warren at the first postwar Kings County Homecoming Days celebration in 1946. Warren attended because of the efforts of Kings County district attorney Roger Walch and Hanford *Sentinel* publisher Stan Beaubaire. (Courtesy Ruth Gomes Collection, Kings County Library.)

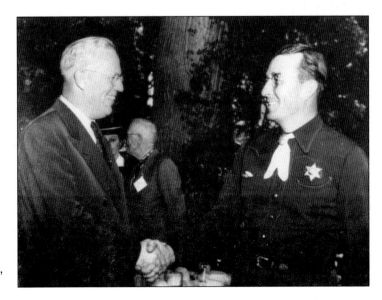

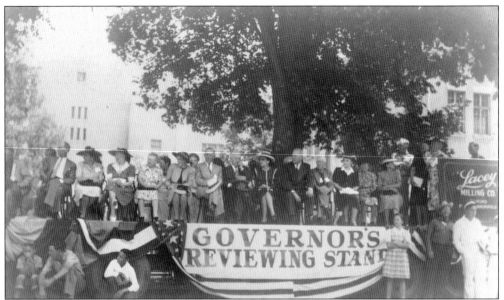

Governor Warren was given a place of honor on the judges' reviewing stand for the May 7, 1946, homecoming parade. Joining the governor on the stand from left to right are Judge Meredith Wingrove, unidentified, Mrs. Cunningham, unidentified, Clara Troutner, Kings County supervisor Russel Troutner, unidentified, Charlotte Walch, Governor Warren, Frank Pryor, and Dana Duffield. (Photograph donated by Charlotte Walch; courtesy Kings County Library.)

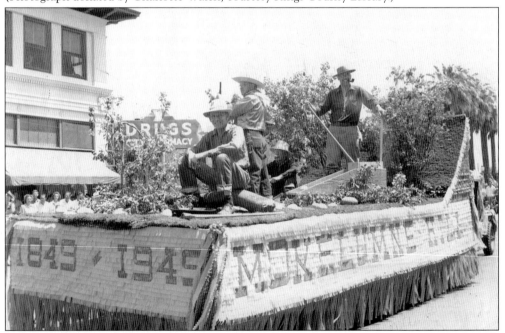

The 1949 Pioneer Days celebration coincided with the statewide celebration of California's centennial. On this float, commemorating the famous Gold Rush town of Mokelumne Hill, are Hanford City councilmen Otto Gribi, Arthur Hird, and Roy Pelgjdn. The fourth man is unidentified. The 1949 celebration kicked off a yearlong series of events that culminated in the 1950 Pioneer Days celebration. (Courtesy Kings County Museum.)

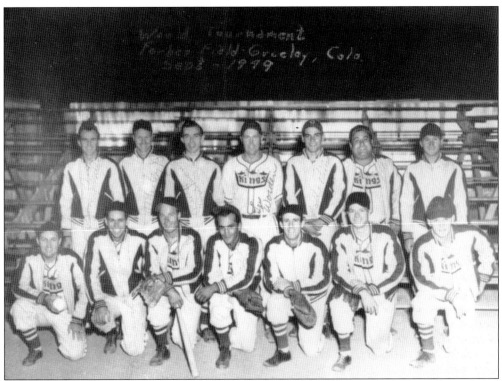

On September 8, 1949, the Hanford Kings won the World Softball Championship Tournament at Forbes Field in Greeley, Colorado. Shown from left to right are the following: (first row) Herb Harris, Kermit Lynch, Ivan Crawford, Dom Faruzzi, Al Cotti, Jack Mashburn, and Bill Rapp; (second row) Lou Ferrero, Whitey Becknell, Bill Horstmann, Les Worden, Freddy Vierra, coach Ray Felix, and Bill Buckley. (Photograph donated by Al Cotti; courtesy Kings County Library.)

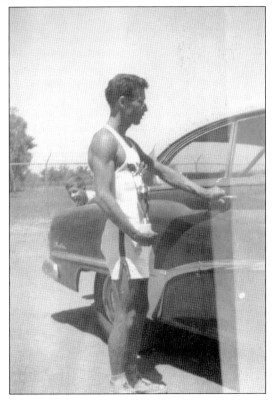

Richard Vierra, Hanford High School class of 1944, attended Fresno State, where he was coached by Dutch Warmerdam. A member of the West Coast Relays Hall of Fame, in 1948 he came from a lap behind to win the 5,000-meter run in record time. He ran for the famed San Francisco Olympic Club but missed the 1948 Olympic Trials because of illness. (Courtesy Vierra family collection.)

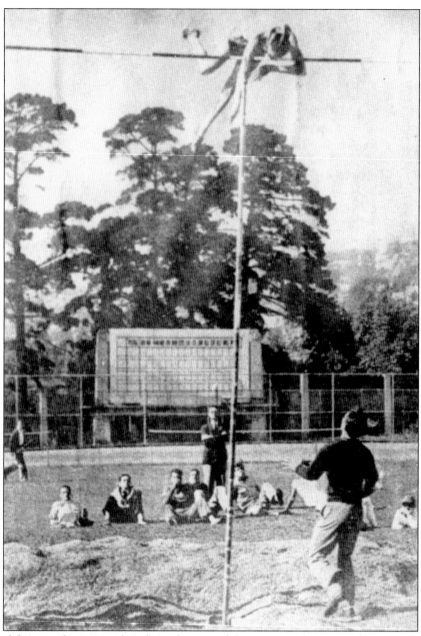

In one of the most famous single pole vaults in track history, Dutch Warmerdam, Hanford High School class of 1932, set the World Outdoor Record of 15 feet 7¾ inches on May 23, 1942, at the Modesto Relays. His highest vault was 15 feet 8½ inches indoors at the Chicago Relays in March 1943. He was the only person to clear the "unreachable" height of 15 feet with a bamboo pole and did it 43 times—no one else has ever done it once. His outdoor record stood until 1947, when it was broken by a vaulter who used a fiberglass pole. He later coached track at Fresno State from 1947 until 1980. The track there was later named Warmerdam Stadium in his honor. The North American Pole Vault Association named him the "Greatest Vaulter of the 20th Century" in 2000. On September 13, 2001, the City of Hanford honored their native son by naming Dutch Warmerdam Drive after him. (Courtesy Kings County Library.)

Six

RISE OF THE SUBURBS
1950–1959

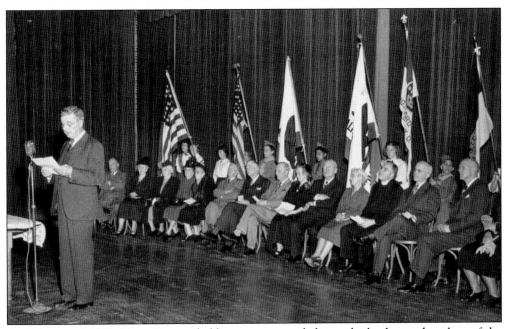

On February 4, 1950, Kings County held a ceremony to dedicate the leaders and workers of the Kings County California Centennial. Marvell Lowe is at the microphone. From left to right are (seated) Dr. Earl Rhodes; Pearl Paterson Locknare; Dora Patterson Baynes; Mary Patterson White; Nettie Gregory; Bart Patterson; Dr. Rockwell Hunt, College of the Pacific; Russell Troutner, chairman of the Board of Supervisors; Leona Kreyenhagen Beckner, chairperson of the Kings County Centennial Commission; Joseph R. Knowland, chairman of the California Centennial Commission; Marvell Lowe, Lemoore; Rev. Richard Upsher Smith, rector, Church of the Savior; Rev. Dean Babbitt, Presbyterian church; and Rev. Harry Tuttle, Christian church. (Courtesy Kings County Museum.)

Children of the pioneer Brooks family and children of James Patterson, leader of the settler group at the Mussel Slough Tragedy, are recognized at the centennial. Photographed from left to right are (first row) Mary Brooks Bowbray (the covered wagon baby), Georgia Brooks, Susan Brooks Lowry, and Clarence Ames ?; (second row) Mary Patterson White, Pearl Patterson Lackmare, Bart Patterson, Netta Gregory, and Dora Patterson Bane. (Courtesy Kings County Museum.)

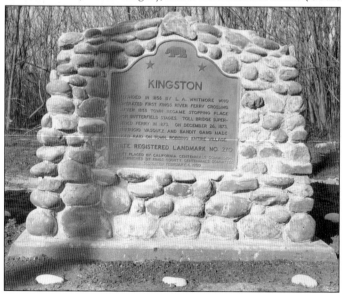

California Historical Marker No. 270 for Kingston was dedicated February 4, 1950, as part of the Kings County celebration of the California Centennial. For more information see chapter three in the first Hanford book. (Courtesy Kings County Museum.)

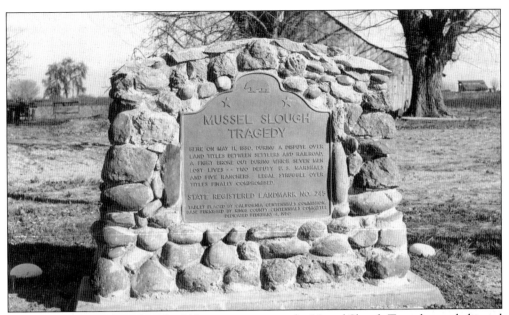

California Historical Marker No. 245 commemorating the Mussel Slough Tragedy was dedicated February 4, 1950, as part of the Kings County celebration of the California Centennial. For more information see chapter six in the first Hanford book. (Courtesy Kings County Museum.)

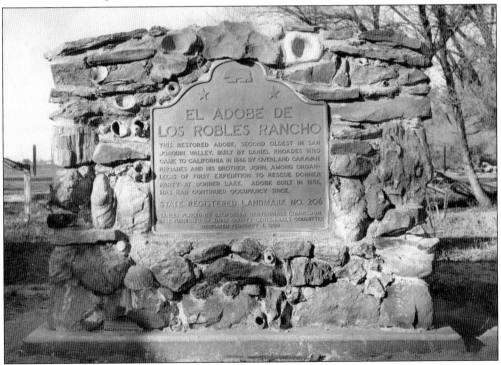

California Historical Marker No. 206 commemorating the El Adobe de Los Robles Rancho was dedicated February 4, 1950, as part of the Kings County celebration of the California Centennial. For more information see pages 34 and 35 in the first Hanford book. (Courtesy Kings County Museum.)

By the 1950s, houses from Hanford's early days were deteriorating. The trend in housing was toward suburbs, but the city made an effort to preserve some of the older homes. The first Hanford subdivision was Short Acres, begun in 1946 by Laurence and Madelyn Short. In the 1950s, the Porter subdivision, Sarita Gardens, the Taylor-Wheeler tract, the Leoni tract, and the Crass subdivision were all developed as suburban housing developments. (Courtesy Kings County Library.)

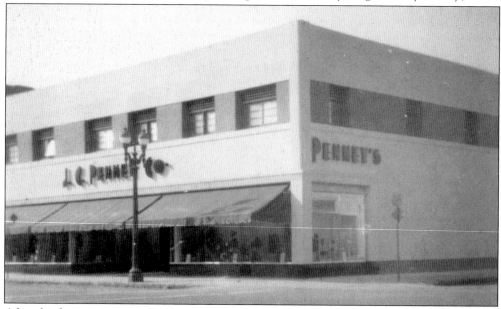

After the devastating 1942 fire (page 66, top), the J. C. Penney store was rebuilt. Shown about 1950, it is difficult to detect the rather inferior wartime materials with which it was built. It was later torn down after Penney's moved to the Kings Mall in 1967 (see page 119, top) and replaced by Wells Fargo Bank. Today it houses the Kings School Systems Credit Union. (Courtesy Hanford Carnegie Museum.)

This photograph was taken on July 4, 1951, before the water tank at the Santa Fe Depot was torn down. Today a bank sits approximately where the water tank was then. The station itself was saved from the wrecking ball in the late 1980s and renovated in 1991 (see page 118, bottom). It currently serves as the Amtrak station. (Courtesy Hanford Carnegie Museum.)

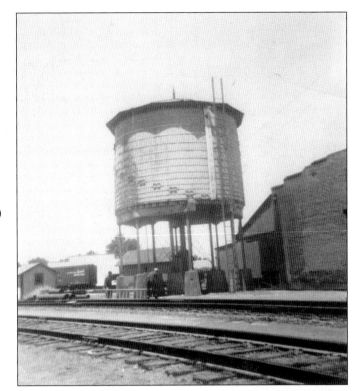

The Hanford High School class of 1907 gathered for its 50th class reunion in 1957. Included in the photograph in no particular order are George Pritchard, Addie Wilkenson, Gladys Bartlett, Bess Cortner, Ethel Farmer, Mrs. Justin Miller, ? Moody, R. Justin Miller, Karl Latimer, Jewel Murray, Charles Furby, George Murray, Irene Manning, Cora Gill, Edwin Haggard, Mrs. E. Haggard, Maurice Macey, Etta Pillsbury, Greta Boyd, Harold Weisbaum, Irma Heisel, Ryta Manasse, and Helen (sister of Ryta). (Photograph by Powell Studios; courtesy Hanford Carnegie Museum.)

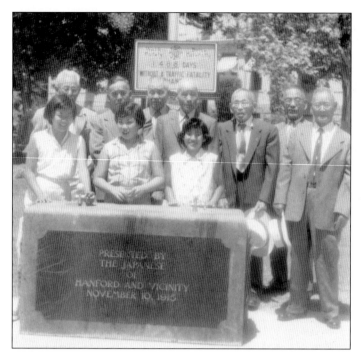

Originally dedicated in 1915 (page 29, bottom), this fountain was dismantled and stored in the courthouse during World War II. Shown at the 1959 rededication on the corner of Irwin and Eighth Streets are, from left to right, the following: (first row) Donna Inaba, ? Funahasi, and Kathy Omata; (second row) ? Fukauda, ? Matsubara, unidentified, ? Miya, Sakutaro (George) Tagawa, ? Habara, and ? Funahashi. The fountain was recently moved back to its original location on the corner of Douty and Eighth Streets. (Courtesy Naomi Tagawa.)

Here is the Hanford Municipal Club at a January 1950 meeting in the civic auditorium. From left to right are W. D. Johnson, Mr. and Mrs. Harris Bales, Mr. and Mrs. Simas, Mr. and Mrs. Tom Bomer, and W. E. Morton. (Courtesy Kings County Museum.)

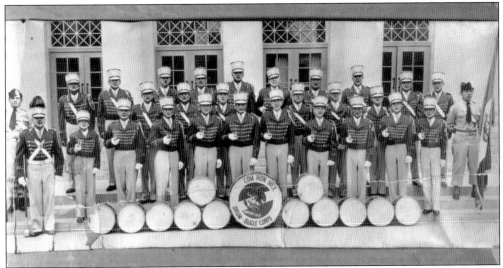

The above photograph shows the Comicion Honorifica Mexicana Drum and Bugle Corps, which was organized in 1952. They participated in competitions throughout the state, winning the state championship in 1962. Pictured from left to right are the following: (first row) Peter B. Garcia, Raymond Resendez, Nat Garcia, Lawrence Valdez, Ernie Martinez, Jess Barrios, Sam DeSantos, unidentified, Manuel Appodoca, Manual Casarez, and Oscar Casarez; (second row) unidentified, Henry Moran, Manual Ramirez, Cruz Valdez, Mr. Garcia, Paul Reyes, unidentified, and Jess Duran; (third row) Andrew Gonzalez, Frank Resendez, Raymond Guerrero, Willie Gomez, unidentified, Fred Ybarra, James Resendez, Eddie Gonzalez, Jess Moran, and John Casarez. The Comicion Honorifica Mexicana promoted Mexican culture and participated in civic events. In 1958, the group held its installation of officers in the civic auditorium, as shown below. (Photograph donated by Angie Duran and Connie Sarco; courtesy of Kings County Library.)

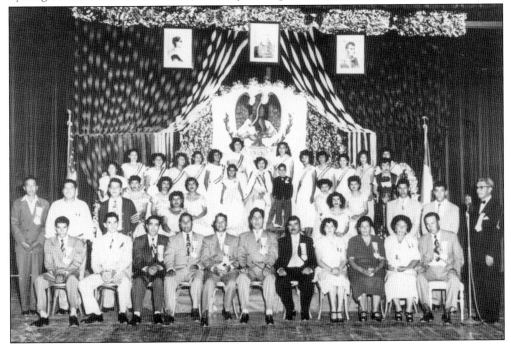

Hispanic leader Cesar Chavez founded the Community Service Organization chapter in Hanford around 1953. The notoriety that later surrounded Chavez was not apparent at the time, but Hanford, with the biggest vineyard in the world (the Lucerne Vineyard, page 17) and its ties to the Gallo Brothers Wine Company certainly noticed him when he led the United Farm Workers Union in a national table grape boycott in 1965. (Courtesy R. M. Roberts.)

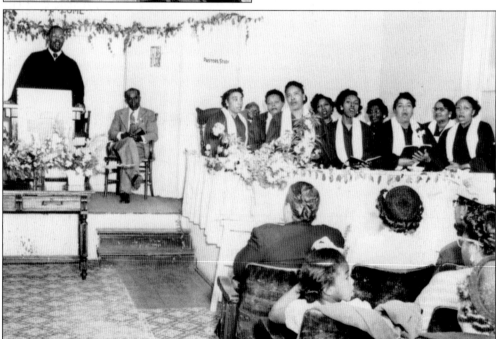

In 1952, the Second Baptist Church, under the leadership of Rev. Matthew E. Crawford (at the pulpit), broke ground for a new sanctuary building. That service is pictured above. Located at the northwest corner of Irwin and Second Streets, the new building was completed in 1954. The original building, built before 1900, was converted to a social hall. (Photograph donated by Alma Carter; courtesy Kings County Library.)

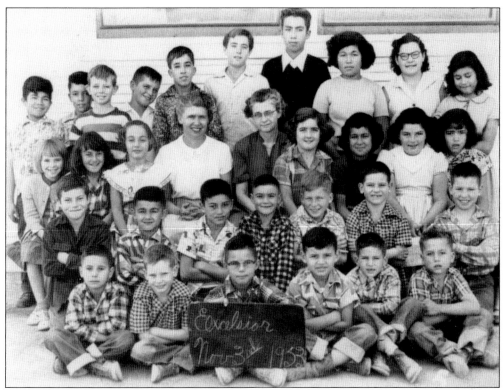

Here is the Excelsior School third-grade class on November 3, 1953. The principal was Thelma Rudholm Williams. The Excelsior District was created on May 4, 1875. In 1958, it was annexed by the Kings River School District. The building was sold to the Christian Reformed Church and moved to Twelfth and Flint Avenues, where it remains in use on the campus of Hanford Christian School. (Courtesy Kings County Museum.)

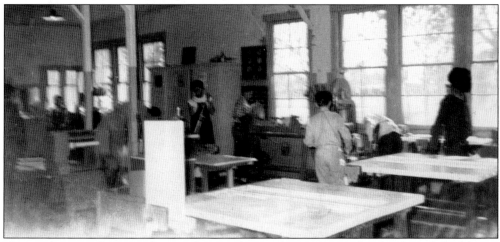

Here students are shown working in the Woodrow Wilson Junior High School wood shop during the winter of 1956–1957. Built in 1925, the old school failed to meet earthquake safety standards in 1959, and the Kings County Grand Jury for that year reported on the unsafe conditions. It took until April 1964, however, for a new school to be opened; that school continues in use to this day. (Courtesy Vierra family collection.)

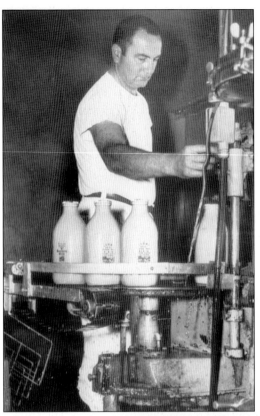

Frank Leoni is photographed bottling milk at his retail milk store on north Eleventh Avenue in 1958. The retail concept was a move away from the traditional delivery of milk and coincided with the rise of the suburbs and commuting. The idea caught on, and soon milk deliveries were a thing of the past. Retail milk stores also became a thing of the past as buyers started purchasing their milk in supermarkets. (Photograph donated by Frank Leoni; courtesy Kings County Library.)

In the 1950s, Johnson's Café featured live music on Friday and Saturday nights. In this photograph, Steve's Aggregation plays dance tunes for the weekend crowd. (Photograph donated by Derral Hawkins; courtesy Kings County Library.)

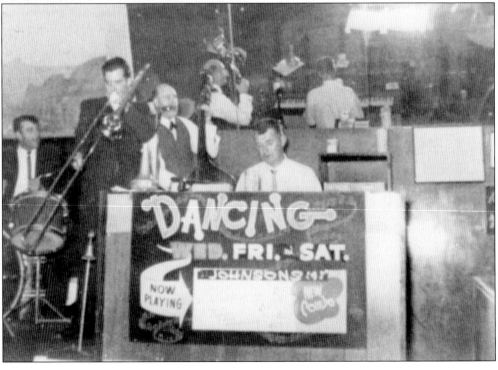

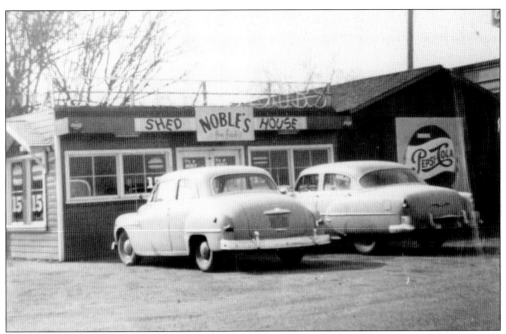

One of the more popular night spots around Hanford during the 1950s was Noble's Shed House on South Tenth Avenue (above). Out front was a restaurant featuring a Noble's burger for 15¢. Out back was the dance floor and outdoor theater. Noble's catered to the country-western music crowd and featured topflight country-western music, including such big-name stars as Ernest Tubbs, Hank Snow, and Kitty Wells. Country-western star Jean Shepard started her career at Noble's Ranch. Shown below are the Maddox Brothers and Rose Hillbilly Band. (Photograph donated by Iileen Fosberg; courtesy Kings County Library.)

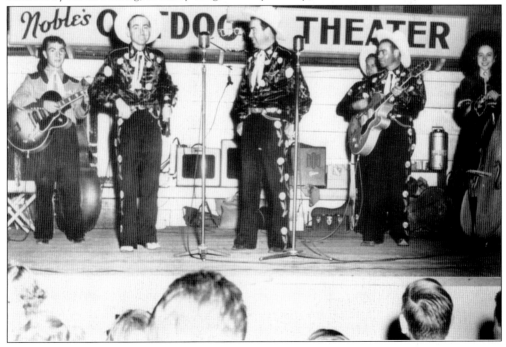

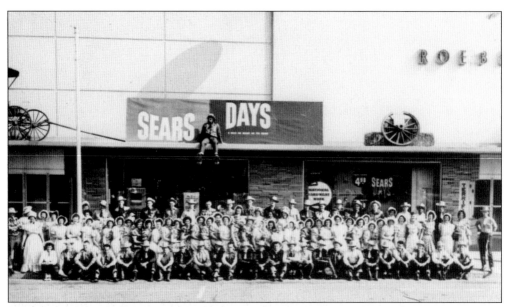

Sears celebrated National Hardware Week in 1951. The employees dressed in western clothing, and hay bales were scattered around the store interior with wagons and farm equipment in the parking lot. The building pictured on Seventh Street was left vacant when the store moved to the Hanford Mall in the 1990s. Attempts to find new tenants remain unsuccessful to this day. (Photograph donated by Belle Bogan; courtesy Kings County Library.)

The Kings County Library is pictured prior to consolidation with the Hanford City Library. The two libraries were originally separate but combined in 1912 and operated from the Carnegie Library building. In 1935, they separated again, with the county library moving to the basement of the courthouse. Later it moved to this building on Lacey Boulevard near Redington Street. In 1968, the two libraries were again combined in the current building (see page 96). (Courtesy Kings County Library.)

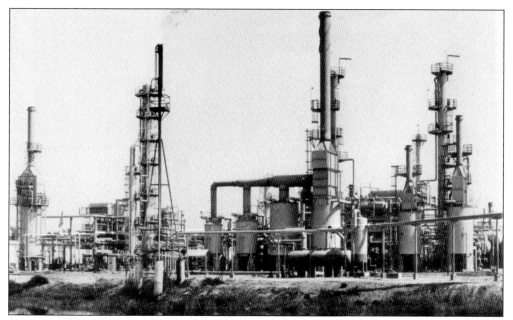

Shown in the 1950s, the Beacon Oil refinery was a Hanford landmark, as well as its largest employer to that time. In the 1980s, Beacon Oil reformed under the Ultramar name. The refinery was dismantled in the 1990s, but the company maintains an administrative headquarters at the site. The grounds of the refinery itself remain empty today. (Courtesy Ruth Gomes Collection, Kings County Library.)

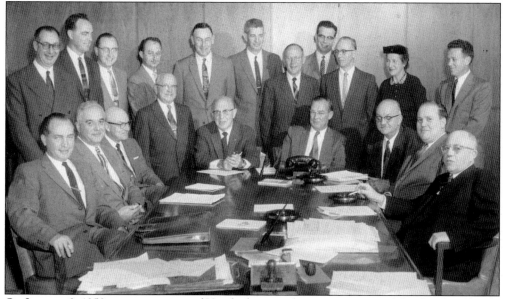

On January 9, 1958, representatives of Hanford met with representatives of the Crocker-Angelo Bank in San Francisco to sign a $3 million bond for a new water system. Representing Hanford were City Clerk Arthur Hird (sitting fourth from left), Mayor Joseph Longfield (sitting fifth from left), City Treasurer Don Anderson (standing fourth from left), City Attorney Clarence Wilson (standing fifth from left), and City Manager George Menturu (standing sixth from left). (Courtesy Hanford Carnegie Museum.)

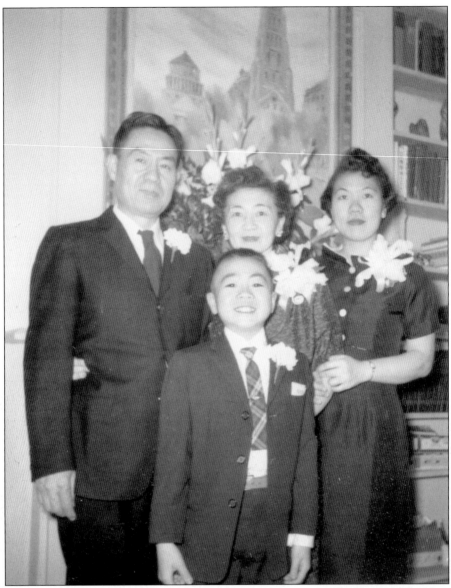

The Henry Sugimoto family is pictured in their New York home in 1958. Photographed from left to right are Henry Sugimoto, Susie Sugimoto, Madeline Sugimoto, and Philip Sugimoto (in front). Henry, a 1921 graduate of Hanford High School, married Susie Tagawa of Hanford on April 24, 1934, in the Japanese Presbyterian Church (page 50, bottom). He became the foremost Japanese American artist in the country with paintings on permanent exhibit in the Smithsonian Institute, the Hiroshima Peace Memorial, the Japanese American National Museum, and the Crocker Art Museum. He has exhibited in San Francisco, Los Angeles, New York, Paris, and Tokyo and also in the Library of Congress and at the San Francisco and San Diego World's Fairs. He was elected to the San Francisco Art Association and the Foundation of Western Art "Hors de Concours," and he received a gold medal at the San Francisco World's Fair in 1939. His invited one-man shows include performances at the California Palace of Legion of Honor Museum in San Francisco, the Baltimore Municipal Museum, the Common Council Hall, and the International Gallery in New York as well as shows in Tokyo, Nagoya, and Osaka, Japan. (Courtesy Naomi Tagawa.)

Seven

A Decade of Change
1960–1969

The Kings County exhibit at the 1961 California State Fair featured a variety of agricultural products produced in the county. Titled "Home of Plenty," the exhibit provided plenty of healthful, free samples of almost every imaginable fruit or vegetable grown in America. Included in the display were boxes of Earl Fruit Company grapes and cans of Red Feather brand apricots and free yellow peaches. (Courtesy Ruth Gomes collection, Kings County Library.)

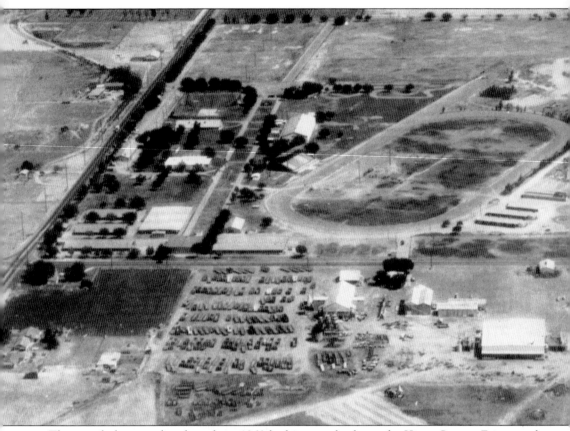

This aerial photograph, taken about 1960 looking north, shows the Kings County Fairgrounds on the left and the Kings Speedway on the right. The central mall of the fairground is plainly visible as are the grandstand and garages of the racetrack. The Kings Speedway is a three-eighths-mile, oval, clay racetrack that hosts sprint cars, stock cars, IMCA and USAC midgets, and a one-eighth-mile modified midget track (see page 68, top). Hanford is to the north, off the top of the photograph, separated from the fairground by the new city cemetery. The airport is just to the east, off the right edge of the photograph. Fair entertainment has included concerts by many notable country-western, rock-and-roll, and pop stars. Since this photograph was taken, a Kings County Fire Department Station was constructed near the southwest corner of the fairgrounds. (Courtesy Kings County Library.)

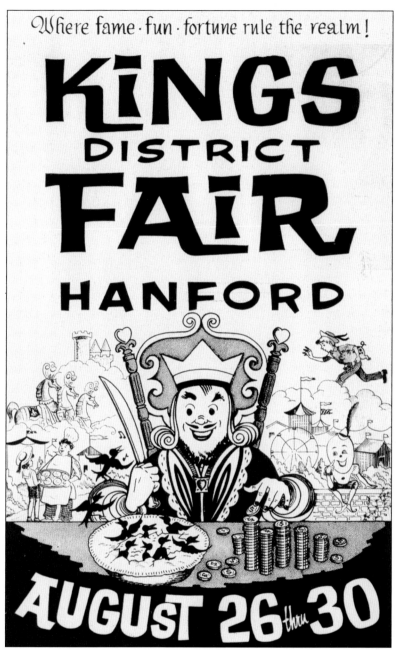

The Kings County Fair has always been a big part of the life of Hanford—particularly to those involved in traditional agricultural pursuits. The dates of the Kings County Fair have varied through the years, but fairs have tended to be held during the summer in recent years. As this poster from the 1960s shows, the third week of August before school started was fair time. The poster does not include a year because the Wednesday through Sunday days of the fair fell on the same dates every five or six years, allowing the posters to be reused. For instance, the poster pictured here could be used in 1959, 1964, and 1970. As recently as the early 1950s, however, the fair was held in October. During the 1980s, it was held during the first week of June and is currently held in mid-July. (Courtesy R. M. Roberts Collection.)

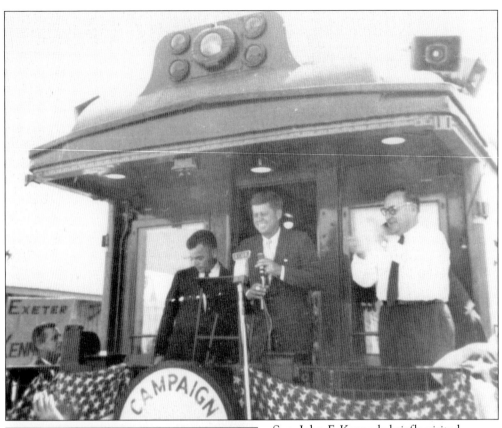

Sen. John F. Kennedy briefly visited Hanford during a "whistle stop" railroad tour through the San Joaquin Valley during the 1960 presidential campaign. Less than four years later, the city mourned his death from an assassin's bullet. (Photograph donated by Don Giacomazzi; courtesy Kings County Library.)

A native of Hanford, Gordon Duffy was elected to the city council in 1962 and became mayor in 1964. That same year, he was elected to the California State Assembly, where he served until his retirement in 1982. Prior to his election to the city council, Duffy was a practicing optometrist and served six years on the Hanford Elementary School Board. (Courtesy Kings County Library.)

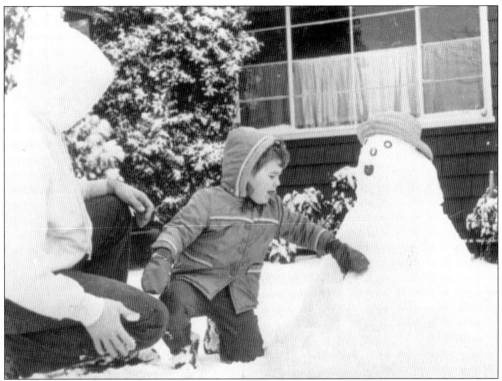

The winter of 1962 was extraordinarily severe nationwide. Several inches of snow fell on Hanford, and even the Lemoore Naval Air Station airfield had to be closed because of snowdrifts. In many places throughout the valley, schools closed or started late because busses were unable to negotiate the snow-covered streets. Not everyone, however, thought the snow was an inconvenience, as this young girl shows. (Courtesy Ruth Gomes Collection, Kings County Library.)

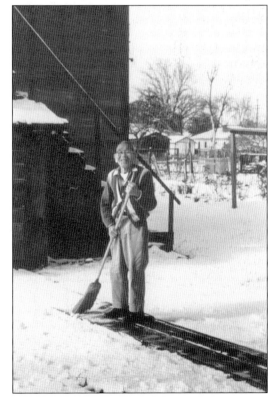

Sakutaro (George) Tagawa was photographed sweeping snow off the sidewalk in front of the Kings Hand Laundry after the record 1962 snowfall. The only other snowfall during the 1960s occurred in 1969. It was extraordinary events like these that led some scientists to start suggesting that the world was entering a new ice age—quite the opposite from the current reports about global warming. (Courtesy Naomi Tagawa.)

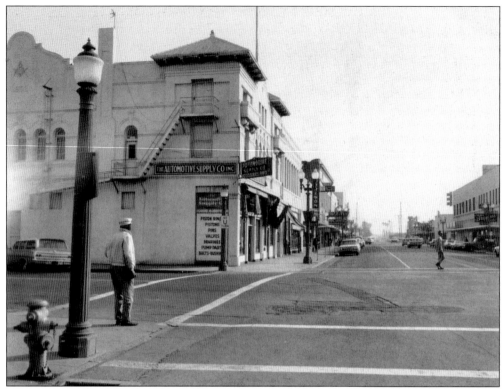

This photograph of the corner of Eighth and Douty Streets shows the Masonic Temple as it looked in 1960. Dedicated May 23, 1902, the second floor is used by the Masons as a meeting room, while the ground floor is rented out. The Automotive Supply Company occupied the first floor when this photograph was taken. (Courtesy Hanford Carnegie Museum.)

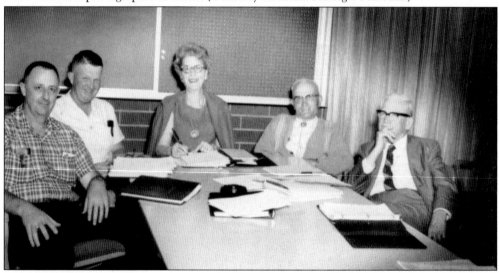

The Hanford Board of Education in the 1960s included, from left to right, Lloyd Paff, Everett Stubaan, Marguerite Vanderburgh, Gerald Schwenk, and Benjamin Pratt. Venderburgh was a longtime principal in the Hartford Elementary School District—at old Washington School and others. (Courtesy Hanford Carnegie Museum.)

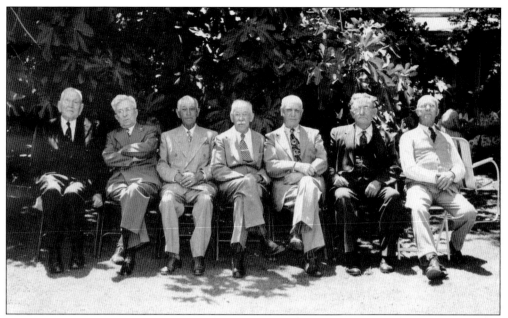

This photograph of former leaders of Hanford was taken during the 75th anniversary celebration on August 12, 1966. Among the festivities was a telephone address by California governor Pat Brown. The former leaders are, from left to right, Judge John Covert, Dr. Charles T. Rosson Sr., J. Clarence Rice, Joe Richmond, Sherman Railsback, Charles Fuller, and John Wilson. (Photograph donated by Judge Robert Rosson; courtesy Kings County Museum.)

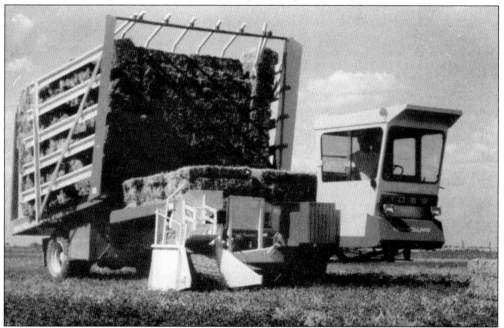

The Holland 1059 hay stacker c. 1965, could pick up bales of hay, automatically stack them in the bin, and tilt-up to deposit a ready-made haystack when fully loaded—all while the operator sat in air-conditioned comfort in the fully enclosed cab. Compare this with the first photograph in the book—farming had come a long way since 1900. (Courtesy Kings County Library.)

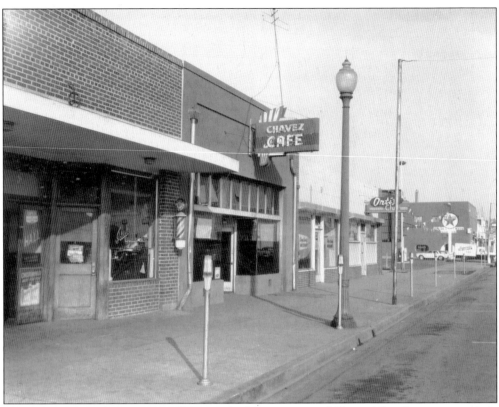

This view of Seventh Street east of Harris is looking east toward China Alley. Businesses include a pool hall, the Ideal Barber Shop, the Chavez Café, Kings County Amusement, the Ortiz club, a Texaco Service Station, and an Italian restaurant. Also note the Superior Dairy truck at the stop sign. (Courtesy Kings County Museum.)

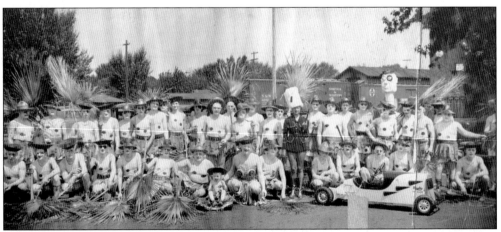

Simply labeled "Powder Puff," this interesting group photograph may be associated with the Girl Scouts' Power Puff Derby, their version of the pine wood derby. The location may not actually be in Hanford, but the group definitely is. The men's shorts all have the word "Hanford" printed on the waistband. The go-kart in front is a Maytag Top Racer. (Courtesy Kings County Library.)

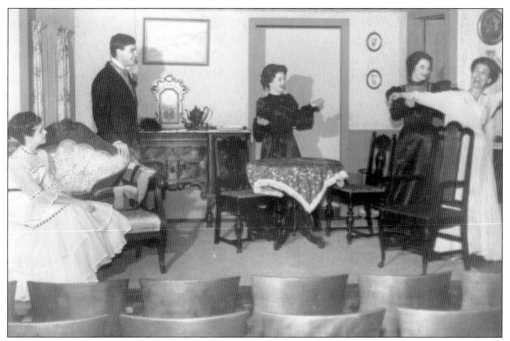

In 1966, the Hanford Players community theater group moved into their new home—the former Chinese school. The cast members shown at dress rehearsal for *Gigi* are, from left to right, Melissa Leibold, Ron Leal, JoAnn Carl, Myrtle Hudson, and Joan Alexander. Melissa's mother, Audrey, was a major figure in the organizing of the group in 1963. (Photograph donated by the Kings Players; courtesy Kings County Library.)

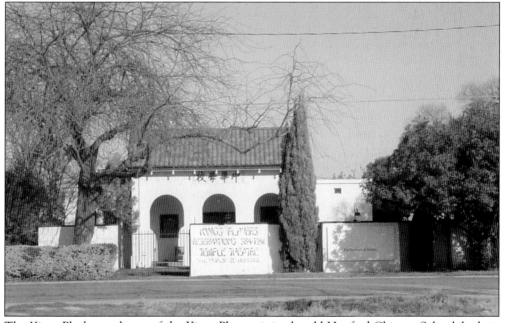

The Kings Playhouse, home of the Kings Players, is in the old Hanford Chinese School, built in 1922. The theater seats 88 spectators and provides an intimate, often participatory experience of theater. The City of Hanford Recreation Department operates it. (Photograph by R. M. Roberts.)

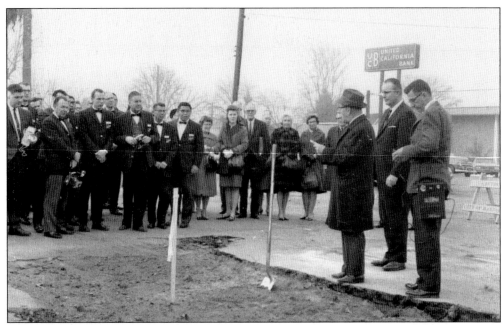

The ground-breaking ceremony for the combined Hanford City and Kings County Libraries took place on a winter day in late 1967. The City of Hanford provided the land and split the cost of the building with the county. Then city manager Vince Peterson, since retired, is now chairman of the Kings County Library Advisory Board, and Wilma Humason, a library board member at the time, still serves on the board. (Courtesy Kings County Library.)

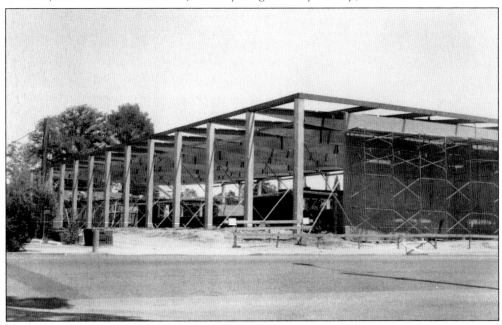

Shown under construction in early 1968, the new library building replaced the venerable Carnegie Library. The city and county libraries shared the building until they were consolidated for the final time in 1975. The Hanford Branch of the Kings County library serves as the main branch of the Kings County Library system. (Courtesy Kings County Library.)

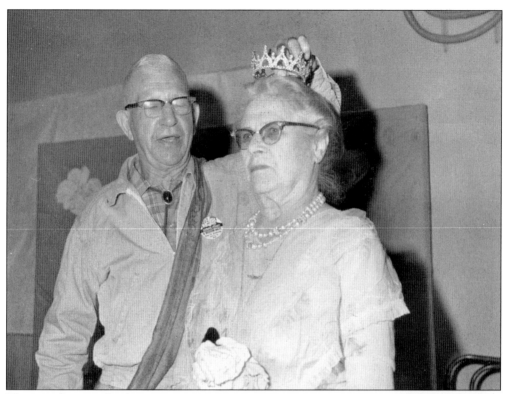

This is a photograph of Irma May Cortner being crowned the 1968 Homecoming Queen. Carrol Ann Buckner was grand marshal that year. The man is unidentified but wears a homecoming shaver permit and western dress button. (Courtesy Hanford Carnegie Museum.)

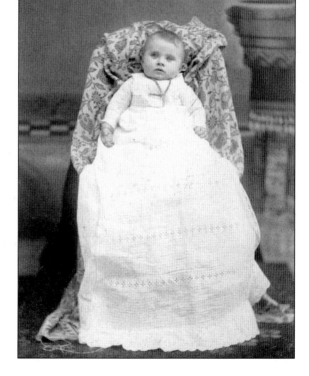

The 1968 Homecoming Queen, Irma May (Fisher) Cortner, is pictured in her baptismal dress in 1886. (Photograph by Morris and Morris of Santa Cruz; courtesy Hanford Carnegie Museum.)

Hanford won the competition to lure the Armstrong Rubber Company's new tire plant to Hanford despite the best efforts of Visalia and Bakersfield. Construction on the plant began in February 1961. Dedicated on December 6, 1962, the Armstrong plant instantly became the largest employer in Kings County history and jump-started the rapid population growth of the 1960s. At its peak, Armstrong employed over 800 employees and produced over 10,000 tires a day. (Courtesy R. M. Roberts.)

At about the same time that Armstrong Rubber Company began construction on its Hanford plant, Tazu and Sakutaro (George) Tagawa were hanging clothes outside the Kings Hand Laundry. This juxtaposition of extremes compares Hanford's smallest and oldest employer, Kings Hand Laundry, with its newest and largest, Armstrong Tire. Hanford has thus far succeeded in balancing this little town–big city dichotomy. (Courtesy Naomi Tagawa.)

Eight

EXPLOSIVE GROWTH
1970–1979

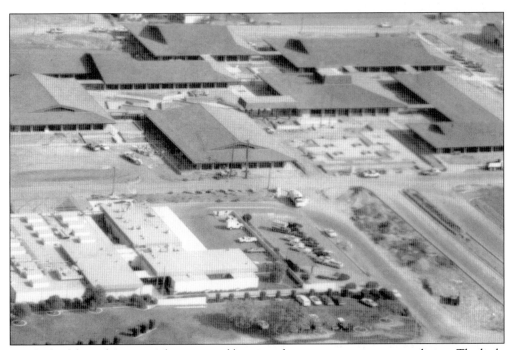

Hanford celebrated America's bicentennial by expanding to meet a surging population. The little town was rapidly becoming a city. Pictured above is the new Kings County Government Center, which opened in 1977. The old courthouse downtown was simply not large enough to contain all the departments and employees necessary for running the county smoothly. (Courtesy Ruth Gomes Collection, Kings County Library.)

As part of the city's bicentennial celebration, a new police station was dedicated on Irwin Street. Prior to 1976, the Hanford Police Department was housed in the basement of the civic auditorium. (Photograph by Alice Stevenson; courtesy Kings County Library.)

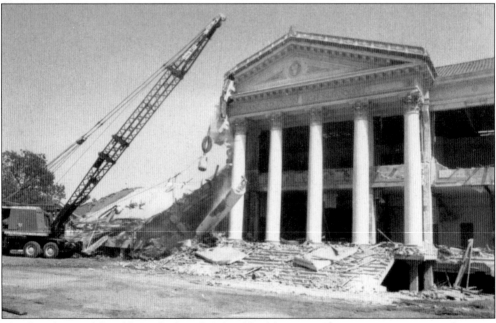

The demolition of the old Hanford High School building in 1975 was a traumatic event for many Hanford residents. Not only had thousands of individuals attended school in the building since it was built in 1921 (see page 34, bottom), but its distinctive pillars and architecture had become a Hanford landmark. It was damaged by a large earthquake in 1952 and failed to meet the new state earthquake standards. (Courtesy Ruth Gomes Collection, Kings County Library.)

While it could not replace the old Hanford High School building, the new presentation center that opened in 1978 met the need for a musical and theatrical venue for both the school and the community. (Courtesy Ruth Gomes Collection, Kings County Library.)

Hanford High School's demolition was not the only case of "out with the old and in with the new." In this 1973 photograph, employees of Kings County General Hospital wave goodbye to the last patients to be treated there. The hospital building is still used by various departments of the Kings County government and the Kings County Office of Education. (Courtesy Ruth Gomes Collection, Kings County Library.)

When the combined Hanford City and Kings County Libraries moved to the new library building around the corner on Douty Street, there was talk of demolishing the old Carnegie building to make room for downtown parking. Concerned citizens mounted an effort to save the landmark building, and in August 1972, renovations began to turn it into a museum. (Courtesy Hanford Carnegie Museum.)

Restoration of the Hanford Carnegie Museum, which had been leased from the city of Hanford for $1 a year since May 22, 1972, was completed March 14, 1974. Taken in 1988, this photograph shows visitors at a Carnegie Museum open house. The Carnegie Heritage League was formed in the fall of 1974 to support the museum. The first home tour benefiting the museum was held April 15, 1975. (Courtesy Hanford Carnegie Museum.)

Like the Carnegie Museum, the Taoist Temple in China Alley was restored during the 1970s and turned into a museum and showpiece of Chinese culture and local Chinese history. Located next door to the world-famous Imperial Dynasty, visitors to Hanford's China Alley, like those in this 1983 photograph, typically include the temple on their tour. (Photograph by Alice Stevenson; courtesy Kings County Library.)

A memorial to longtime Kings County supervisor and historic preservationist Evon Cody was placed on the grounds of the new Kings County Government Center shortly after the new center was built. In addition to his service on the Board of Supervisors, Evon was also a longtime member of the county museum board. Evon is pictured as a youngster in the 1920s on page 41. (Courtesy Kings County Library.)

Creation of the Fort Roosevelt ecological center, animal shelter, and zoological museum began as the 1969 vision of Roosevelt School principal Jim Parks. Manned by Heidi Arroues, the fort welcomed thousands of visitors over the years and became a Hanford landmark and visitor attraction. Sadly Hanford Elementary School District leaders elected to dismantle the fort in 2006 rather than face the costs of a major renovation. (Photograph by Alice Stevenson; courtesy Kings County Museum.)

The Hanford Renaissance of Kings began in 1977 as way to make money for local civic organizations following Proposition 13 cutbacks. Cathy Gregory, longtime recreation director for the city, was one of the original organizers. It is now run by the Tudor Rose Society, and every October, Courthouse Park goes back in time to become Hanfordshire during the reign of King Henry VIII of England. (Photograph by Hanford *Sentinel*; courtesy Kings County Library.)

In a decade already replete with firsts, on September 5, 1977, Mary Umbaugh (right) became the first female deputy sheriff in Kings County history. She became a correctional officer in December 1988 and retired January 28, 1994. She died August 9, 1996, aged 49. (Courtesy Kings County Library.)

On the float with 1978 Homecoming Queen Maude Montgomery (left) are Dan Humason and Alice Collins. Maude was the wife of Hanford High School vice principal and California state senator Robert Montgomery and was a "prime mover" in the effort to preserve historic Hanford buildings. She donated the historic Traver Jail to the Burris Park Museum, where it remains on display to this day. (Courtesy Hanford Carnegie Museum.)

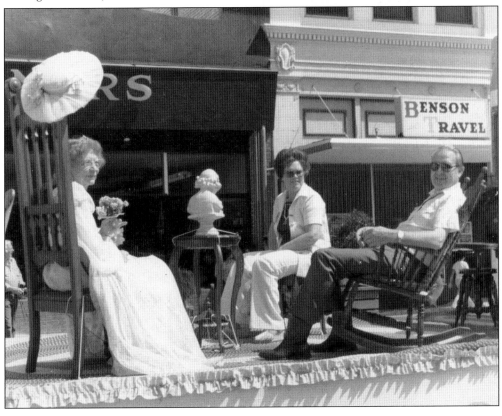

Marchers in the March of Dimes Walk-a-thon move along East Lacey Boulevard in 1973. As an indication of how some things have changed over the years, the sign in front of the new Hanford McDonald's in the background says "Over 10 Million Served." The Giannola family opened the fast-food chain restaurant January 20 of that year. (Courtesy Ruth Gomes Collection, Kings County Library.)

Participants in a Portuguese Folk Dancing event are shown at the Kings Mall during the 1973 "Days of Portuguese Culture." The sign for Thrifty Drug can be seen in the background. (Courtesy Ruth Gomes Collection, Kings County Library.)

As part of their celebration of Kings County Homecoming Days, Beacon Oil Refinery employees vied for honors in an annual tricycle race. In this 1977 photograph, the defending champion is shown practicing for the all-important event, urged on by fellow team members. (Courtesy Ruth Gomes Collection, Kings County Library.)

The annual Christmas parade always features a visit from old St. Nick himself. In 1972, as shown in this photograph, he managed to hitch a ride on one of the city's new fire trucks. The parade is headed north on Irwin Street past the Cross Roads Store and the Crocker Bank. The Hanford High School marching band can be seen following the truck. (Courtesy Ruth Gomes Collection, Kings County Library.)

Among the many graduates of Hanford High School was Nobel Laureate James Rainwater, class of 1935. He was admitted to Cal Tech through an open chemistry competition where he studied under Nobel Prize winner Carl David Anderson. After studying with Enrico Fermi and Edward Teller, Rainwater worked on the Manhattan Project during World War II. He had to wait until after the war for his thesis to be declassified in order to receive his Ph.D. As a professor of physics at Columbia University, he developed the theory that certain atomic nuclei had asymmetrical properties, a hypothesis later proved by Aage Bohr and Ben R. Mottleson with whom he shared the 1975 Nobel Prize for Physics. Dr. Rainwater also received the 1963 Ernest Orlando Lawrence Prize for Physics from the Atomic Energy Commission. Dr. Rainwater died May 31, 1986. (Courtesy R. M. Roberts.)

Nine

CHANGING FACE
1980-1989

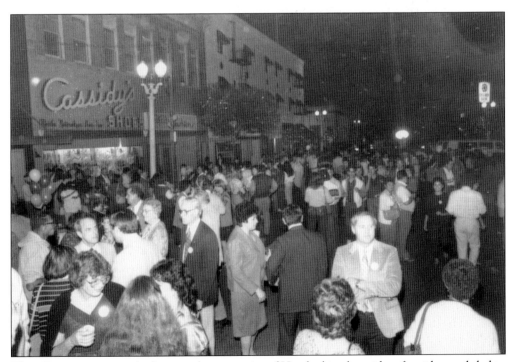

The efforts to preserve the historical community of Hanford in the midst of rapid growth led to the formation of the Historic Resources Commission in 1980. That effort was rewarded when the League of California Cities awarded Hanford the 1985 Helen Putnam Award for Excellence for its downtown historical restoration. The city celebrated the award with a party thrown on Seventh Street in the midst of the historic district bounded by Redington, Douty, Harris and Sixth Streets, shown above. (Courtesy Ruth Gomes Collection, Kings County Library.)

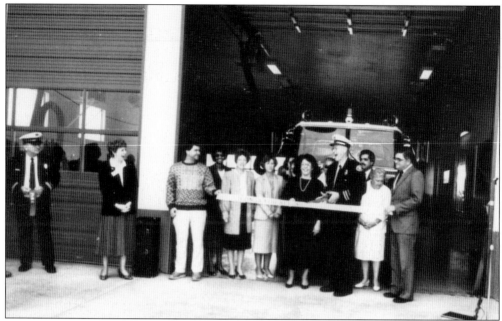

Prominent at the dedication of Hanford Fire Station No. 2 on November 1988 was the old bell saved during World War II (see pages 60 and 61). It is mounted out front, where it can be seen today. Mayor Patt Rapozo and Fire Chief Wesley P. Yeary are shown cutting the ribbon to declare the station "open for business." (Photograph by Alice Stevenson; courtesy Kings County Library.)

During the late 1980s, the Courthouse Square developers obtained a carousel from Mooney Grove in Visalia and moved it onto the grass in front of the courthouse. Hanford's own poet, Wilma McDaniel, wrote the poem "The Carousel Would Haunt Me," when it was moved. This nighttime photograph was taken not long after it went into operation. (Photograph by R. M. Roberts.)

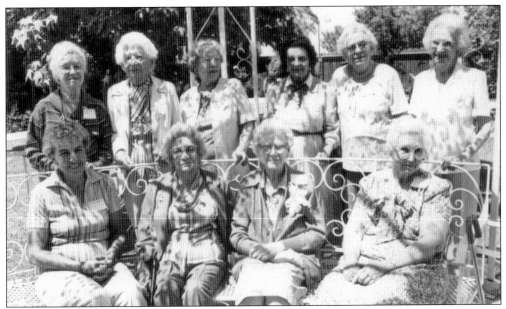

Because this photograph of former homecoming queens was originally taken in 1985, committee member Marjorie Fall (front row, left) was herself selected as a homecoming queen. Photographed from left to right are (first row) Marjorie Fall, Virginia Ferguson (1976), Ora Sullivan Arthur (1959), and Dorothy Maxwell (1981); (second row), Edith Truckell (1979), Maude Montgomery (1978), Claribel Briner (1967), Gloria Dias (1985), Margaret Hird (1983), and Vera Nelson Johnson (1980). (Courtesy Ruth Gomes Collection, Kings County Library.)

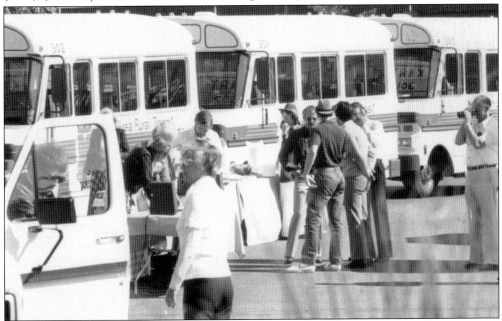

In the 1970s, the Kings Area Rural Transit (KART) system was initiated to provide affordable transportation for those unable to transport themselves. In 1980, when this photograph was taken, KART held an open house to answer questions and publicize its services. (Courtesy Ruth Gomes Collection, Kings County Library.)

In addition to the Helen Putnam Award in 1985, Hanford was named a Tree City USA three years running—1988, 1989, 1990—by the National Arbor Day Foundation. In this 1991 photograph, Hanford schoolchildren are shown placing a yellow ribbon in honor of the award on a newly planted tree. (Photograph by Dave Rantz; courtesy City of Hanford.)

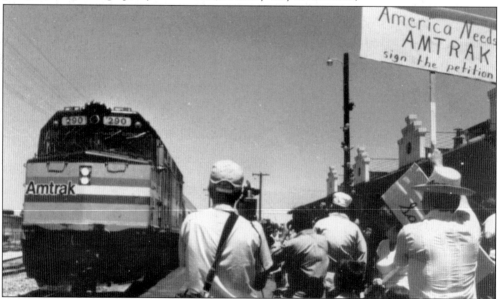

During the early 1980s, there was some question about whether the Amtrak passenger trains were viable. In order to persuade government officials that service should be continued, the towns and cities serviced by the trains demonstrated their support by declaring June 1, 1985, Amtrak Day. Thousands turned out up and down the tracks, and the officials got the message. Amtrak continues to run today. (Photograph by Alice Stevenson; courtesy Kings County Museum.)

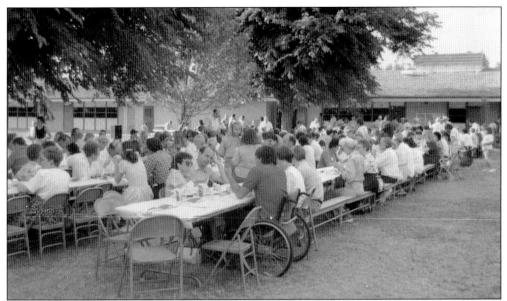

In May 1995, Pioneer Union Elementary School celebrated its 125th anniversary. The oldest continuously operating school district in the south valley, the Pioneer School district was created on August 5, 1870—before the town of Hanford existed. Located on Fourteenth Avenue in the heart of what was once the thriving town of Grangeville, current and past students, family, and friends gathered to celebrate the occasion. (Courtesy R. M. Roberts.)

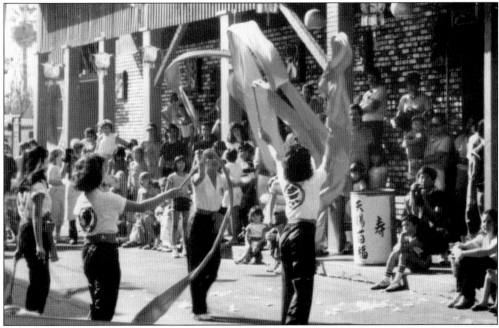

In addition to the Renaissance of Kings and Kings County Homecoming Days, the Chinese Moon Festival attracts tourists to Hanford. Pictured in 1984, Chinese students perform a ribbon dance as part of the celebration. Hanford poet Wilma McDaniel wrote about the China Alley experience in a poem by the same name. (Photograph by Alice Stevenson; courtesy Kings County Library.)

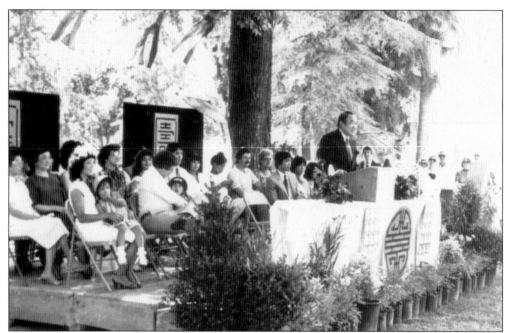

In 1983, Hanford celebrated Wing Family Appreciation Day. In this photograph, Richard Wing thanks the nearly 500 attendees for the honor. The Wing family operated the world-renowned Imperial Dynasty with Richard as chef, brother Ernest as maitre d'hotel and wine master, and sisters Harriet and Emma and Ernest's wife, Bea, taking active parts in the operation. Richard's wife, Mary, was Miss Hong Kong 1964 and competed in the Miss Universe Pageant. (Photograph by Hanford Chamber of Commerce; courtesy Kings County Library.)

Hanford participates in the internationally acclaimed Special Olympics program. This photograph is from the 1986 Kings County Special Olympics held at Hanford High School. (Courtesy Ruth Gomes Collection, Kings County Library.)

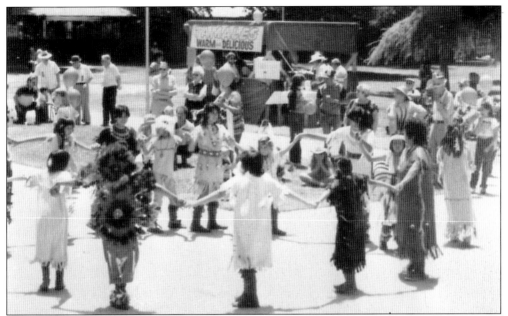

Tachi dancers from the Santa Rosa reservation participate in the 1985 Amtrak Day program by performing some of their native dances. At the time, the Tachi Yokuts operated a successful bingo palace that has since been replaced by a Native American gaming casino at the same location. (Photograph by Alice Stevenson; courtesy Kings County Library.)

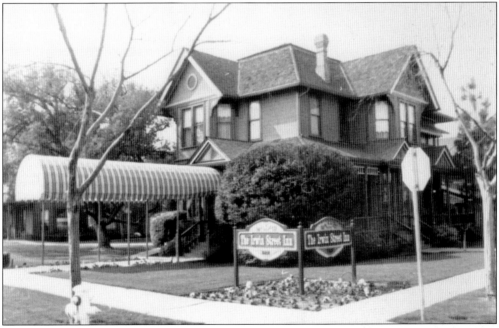

One of the showpieces of the downtown restoration program is the Irwin Street Inn, shown in 1989. Originally restored by real estate developer Max Walden, the complex of Victorian-style houses has been continually plagued by financial difficulties. A number of owners have stepped in over the years to keep it going. Today it is known as the Hanford Victorian Inn. (Photograph by Alice Stevenson; courtesy Kings County Library.)

Faced with failing libraries across the state due to the reductions in property-tax revenues caused by the passage of Proposition 13, libraries around the state began active lobbying for funding by holding an annual Library Legislative Day. In the mid-1980s, the Kings County Library Advisory Board participated in the annual event. Photographed from left to right are Ivan Edelman, Kings County librarian; Bill Wooley; Virginia Scow; Sen. Jim Costa; Robin Roberts; and Wilma Humason. (Courtesy R. M. Roberts.)

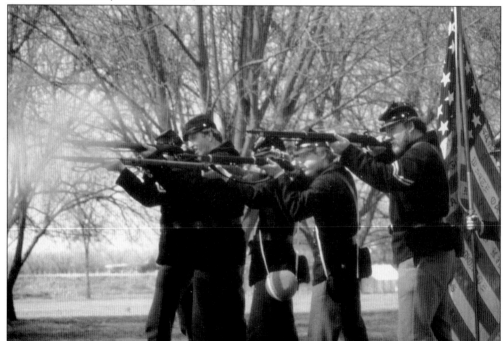

This is a scene from a Civil War reenactment held in Burris Park in the spring of 1985. The park has been host to many special events over the years and is the location of the Kings County Museum. (Courtesy R. M. Roberts.)

Ten

HANFORD CENTENNIAL
1990–2000

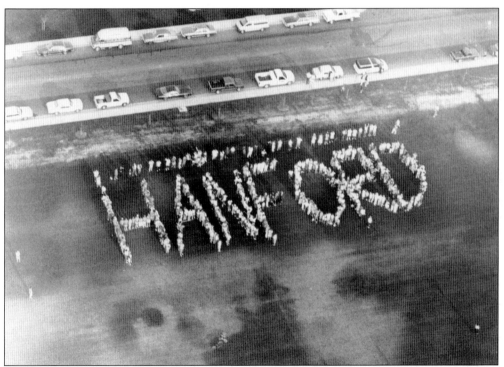

Several hundred people helped kick off the yearlong Hanford Centennial celebration on August 12, 1990, by spelling out the word "Hanford" on the lawn of the Hanford High School west campus, as it was known then. Lacey Boulevard is at the top of the photograph. Dave Rantz took this photograph from a hot air balloon that had lifted off just moments before. Since then, the Hanford west campus has become Hanford West High School—another sign of the growth of the town. (Courtesy Kings County Library.)

Celebrating Hanford's 99th birthday in 1990 with a centennial cake are, from left to right, the following: (first row, children) Donna Archuleta, Kayla Chin, and Leia Chin; (second row) Joyce Hall, Frances Peterson, Carrie Yrigollen, Roxanne Cordova, Janie Costa, Gladys Mendes, Shara Chin, and Pam Chin; (third row) Belle Bogan, Camala Crain, Lila Barros, Cheryl Lehn, County Supervisor Abel Meirelles, Evelyn Crain, and Cathy Gregory; (fourth row) Maxine Jones, Paul Crain holding son, Sean Paul, John Lehn, Vincent Peterson, Mel Mendes, Joe Crain, and Clifford Chin holding son, Ryan. (Photograph by Alice Stevenson; courtesy Kings County Library.)

The old Santa Fe train station is photographed in the midst of extensive renovation during June 1991. It was part of a series of projects for the Hanford and Kings County Centennials. Today it houses the Amtrak station, the Hanford Chamber of Commerce, and the Hanford Visitor Agency. (Courtesy Kings County Library.)

The "old" Kings Mall is shown as it appeared in 1992, shortly before the sign was removed and major renovation began. Located on the northwest corner of Lacey Boulevard and Tenth Avenue, the mall was replaced by the current Hanford Mall just outside of town. Ground breaking for this mall occurred at 11 a.m. on Thursday, July 12, 1966. (Photograph by R. M. Roberts.)

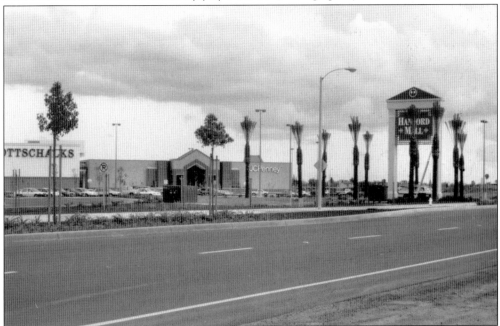

The new Hanford Mall is photographed just prior to official opening day on March 3, 1993. An estimated 30,000 people mobbed the new mall that day. The city council approved the building permit on March 27, 1990, and construction began in 1992. Its construction effectively ended the life of the old Kings Mall and moved the focus of expansion outside the city limits. (Photograph by R. M. Roberts.)

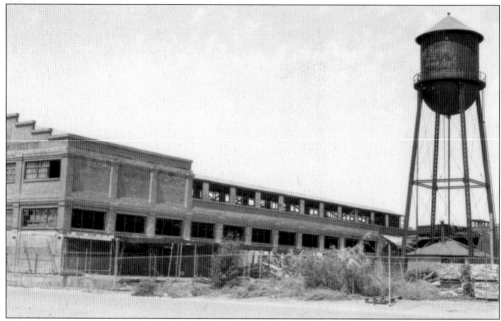

The water tower at the abandoned Del Monte plant was photographed prior to being demolished in 1990. Another sign of the changing times, the Del Monte Plant once employed several hundred people (see page 38, top). (Photograph by Alice Stevenson; courtesy Kings County Library.)

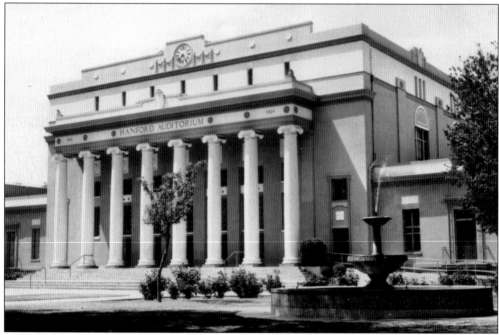

Hanford's civic auditorium is shown as it appeared in 1990 after a centennial facelift. In the foreground is the Pioneer Fountain, dedicated to the pioneers who formed Kings County. Originally the site of Hanford Central School, in 1923 a bond for $195,000 was approved by the voters for its construction. Designed by Coats and Traver and built by Brindle and Bebeau, it was dedicated May 22, 1925. (Photograph by Alice Stevenson; courtesy Kings County Library.)

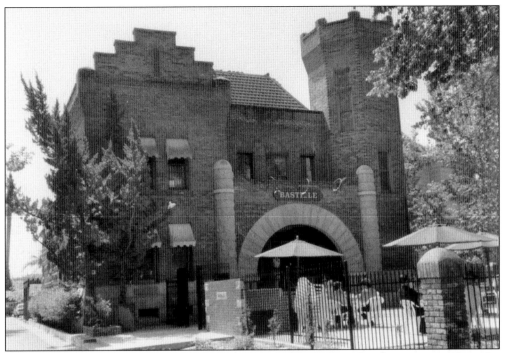

This is the Bastille Restaurant as it appeared in 1990. After serving briefly as an art gallery, the old county jail became a restaurant and bar in the mid-1980s. Live music is usually available in the outdoor area on weekend evenings during the warmer months (Photograph by Alice Stevenson; courtesy Kings County Library.)

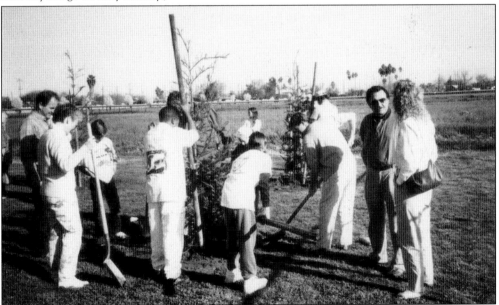

Sponsored by the Hanford Tree Committee, students participate in Arbor Day 1990. Hanford City councilman Art Bartel is facing camera on the right-hand side of the photograph. Efforts like this were why Hanford was designated a Tree City USA. (Courtesy Ruth Gomes, Kings County Library.)

In the early 1990s, GFW Power Systems tried to locate a coal-fired power generation plant in Hanford, but the idea was opposed by most locals. Controversy erupted when the Hanford City Council narrowly approved the GFW building application by a 3-2 vote. Mayor Pat Rapozo was forced to resign after it was learned that she had an affair with the GFW representative, and the other two affirmative voters were not reelected. (Courtesy Kings County Library.)

The NOAA Weather Station in Hanford opened on January 25, 1995 and became the first station to deploy Doppler radar for weather forecasting on March 10, 1995. By the end of that year all forecasts for the San Joaquin Valley were handled from the Hanford office. (Photograph by City of Hanford.)

Beginning in the 1980s, Hanford came to the attention of Hollywood as a location for movies. Films shot in Hanford include *Casino* (1994) and *The Rebel* (1998). In *Real Men*, John Ritter tried to escape from James Belushi in cornfield like this one just outside Hanford. This undated photograph is captioned, "Mr. Drapon of the Kings County Development Company inspecting crops." (Photograph donated by Jack Stone; courtesy Kings County Library.)

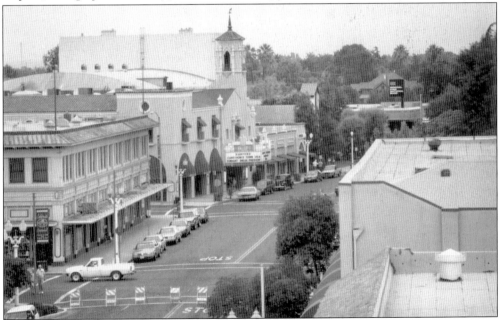

This photograph, taken by longtime Hanford photographer Dave Rantz, shows the intersection of Eighth and Irwin Streets in August 1991. The intersection is blocked off in preparation for a centennial-related event that is not identified, though the marquee on the Fox Theater reads "Hanford Confidence City USA Sneak Preview Tonight." (Courtesy Kings County Library.)

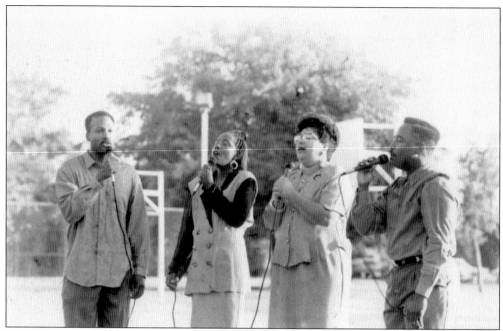

In August 1992, the African American churches of Hanford sponsored an evening of music in Coe Park. Gospel groups from various churches, such as the one pictured above, presented a variety of gospel-themed music. Similar events have been held in the park for many years. (Photograph by Alice Stevenson; courtesy Kings County Library.)

The Kings County Art League has held an Annual Art Show in conjunction with the Mother's Day weekend sidewalk chalk drawing competition. Both activities are held in Courthouse Park. In the particular year shown above, the art show was set up on the Courthouse Mall next the old Kings County Courthouse building. (Courtesy Kings County Library.)

Among the many activities that took place in Hanford during the 1990s was the annual Chili Cook-off. Held in Courthouse Park, the participants vie to produce the tastiest chili. The key to winning, as suggested by these contestants' "All Sauced Up" T-shirts, is the sauce. (Courtesy Kings County Library.)

The Kings County Office of Education held annual technology fairs throughout the 1990s. Around 1998, the fair was held in conjunction with the Academic Decathlon at Hanford High School in the old gym—an interesting juxtaposition of the old and the new. Pictured in the photograph above is the exhibit by Pioneer Elementary School. (Courtesy R. M. Roberts.)

The 1998–1999 Hanford High School State Odyssey of the Mind Champions finished 14th at the world competition held at Disney World even after their electronic equipment was rendered inoperative when inadequate storage provided by Disney allowed the equipment to be soaked the night before the competition. Members, some of which are pictured here, were Shawn Heddon, Melissa Terstegen, Eric Terstegen, Michael Lee, Christina Bettencourt, Steven Moore, and Terra Roberts. Kathy Terstegen and Dottie Moore coached the team. (Courtesy R. M. Roberts.)

The Hanford High School Voices of Illusion squad in 2000 started the new millennium with a new program done in an old way. Shown left to right are Kevin Cordi, sponsor; Raychelle Dickens; Steven Auyeung; Dawn Escobar; Andrew Rivera; Nicole Devol; Jeremey Hanson; and Tamara Roberts. (Courtesy R. M. Roberts)

The Hanford Centennial Time Capsule is photographed being lowered into its resting place in the Auditorium Rose Garden. It is scheduled to be opened in 2041, the 150th anniversary of the founding of Hanford. Mayor Simon Lakritz (right) and Margie Buford (left) guide the capsule as other participants look on. Time capsule committee members were Les Collins, Elsie McNamara, Bel Bogan, Martha Bentley, Eleanor Madruga, Lila Barros, Jane Ellen Bartholomew, and Alice Schneider. In another 50 years, Hanford will be ready for the next book—but someone else will have to write it. (Courtesy Kings County Library.)

Across America, People are Discovering Something Wonderful. Their Heritage.

Arcadia Publishing is the leading local history publisher in the United States. With more than 3,000 titles in print and hundreds of new titles released every year, Arcadia has extensive specialized experience chronicling the history of communities and celebrating America's hidden stories, bringing to life the people, places, and events from the past. To discover the history of other communities across the nation, please visit:

www.arcadiapublishing.com

Customized search tools allow you to find regional history books about the town where you grew up, the cities where your friends and family live, the town where your parents met, or even that retirement spot you've been dreaming about.